DESIGNING

IDENTITY

Graphic Design

as a

Business Strategy

MARC ENGLISH

Rockport Publishers, Inc.

Gloucester, Massachusetts

ROCKPORT
PUBLISHERS

First published in the United States of America by

Rockport Publishers, Inc.

33 Commercial Street

Gloucester, Massachusetts 01930

Telephone {978} 282 9590

Facsimile {978} 283 2742

www.rockpub.com

ISBN 1-56496-680-1

10 9 8 7 6 5 4 3 2 1

Book Design > Marc English : Diseño para Comunicación | Austin, Texas

Printed in China

Text is set in Bembo, cut in 1929 by the Monotype Corporation of England, after the Italian Renaissance fonts of Aldus Manutius of 1490. As you can see, it still does a good job 500 years later. There is something to be said for quality, regardless of when it originates. Heads and captions are set in Frutiger, designed in 1976 by Parisian Adrian Frutiger, known for also designing Univers, OCR-B, Avenir, and Meridien.

FOR REBECKA.

YOUR IDENTITY IS

YOUR HEART &

YOUR SOUL;

A REFLECTION

OF YOUR SPIRIT.

LOVE, DAD

CONTENTS

A MEANS TO AN END
MARC ENGLISH

Communication, Community,
Commerce, and Culture

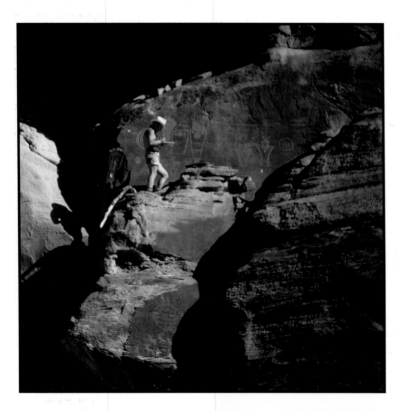

Above, the author, performing an audit of visual communication systems, pertaining to food dispersal. Sort of.

IN 1985 I STOOD ATOP A TALL SANDSTONE BOULDER that leaned precariously from the top of a talus slope against a cliff face. To reach my perch I used nine-hundred-year old handholds, working my way up the few remaining yards by way of a crevice. The flat surface area on which I stood was as wide as I am tall, and twice that in length. Opposite the cliff rose a similar wall, a quarter mile to the east. It being May, Indian Creek ran strong, heading due south, 150 feet (45 meters) below, in the middle of the canyon floor. A verdant strip of small cottonwood and juniper trees bordered the creek, tapering off to the prickly pear, barrel cactus, and desert chaparral of southeast Utah. From my height there was not a sound.

At arm's length, on a small abutment forming a right-angle to the wall and facing parallel to, but away from the creek and canyon, an image had been laboriously pecked through the eon-old stone patina, exposing the lighter stone beneath. An elk, complete with net, had been carved. Though unseen from below, it would have meant much to those who knew to look for both it and its meaning. In this region where the pre-Columbian Anasazi and Fremont cultures overlapped, both peoples would have been able to understand the simple markings: a good place to hunt. Food.

At the time, I was part of a small research team documenting petroglyphs—images carved in stone—and pictographs—images painted on stone. Ostensibly, my task was to commit the images to paper before time or vandals took their toll on the rock art. For myself, I was beginning to comprehend the roots of graphic design—of visual communication—in North America.

If we look at the development of human communication, it follows a fairly simple line: ideas or thoughts lead to grimaces, grunts, and eventually speech. Symbol-making gave visual form to speech, and, in turn, developed into writing. Physicist Stephen Hawking suggests that at this point, humans no longer transmitted new information within their DNA, but externally. We have grown, in one sense or another, from cult to culture, because of communication. That may be too alliterative for some, but one root of civilization is cultivation, the tilling of land. To take it a step further, the cultivation and growing of communication, be it about planting seasons, dangers, or spiritual harmony, has been a wellspring of human advancement.

The petroglyphs served as pneumonic devices—memory aids. These aids persist in our times, though the majority no longer represent clans. Or maybe they do. Specific areas of commerce, each with their unique and often overlapping audiences, have developed languages and symbols of their own, each identifying their position in the world.

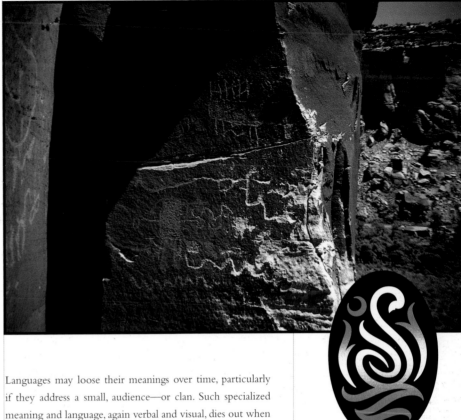

The shorthand term for these symbols is "logo." From the Greek *logos*, meaning "word" or, to be more specific, "the word" or "the way" in terms of cosmic reason and the source of world order and intelligibility. According to the Gospel of John, the term is used in reference to the self-revealing thought and will of God. From its simplest origin, logo refers to representation that symbolizes and communicates a meaning or idea. At its most complex and divine, it suggests a sublime essence.

While writing on the art of drawing, Alfred M. Brooks revealed an understanding of the mastery on this "sublime essence" in a thoughtful, though rhapsodic paragraph:[1]

> The difference between good tree drawing, and transcendent, hinges wholly upon an artist's comprehension of nature's order, and the degree of his faith in, and respect for, that order. Her basic, everlasting order, her changeless course, when it comes to art, have their analogy in what is called design. It is design alone that can lift drawing, tree drawing or any other, from the plain of good to the peak of transcendency. Good tree drawing as I have defined it, and I would emphasize its rarity, is camera-minded, whereas transcendent tree drawing, Titian's, Rembrandt's, Turner's and Corot's, is creative-minded. Beneath what looks so natural … there is a framework or pattern …which, put there consciously, unconsciously affects the beholder with the same reverent and delighted feeling, close kin to worship, that he has when he looks on nature in all her infinite dispensations. Such a man bows before the infinite, and, in bowing does that infinite the supreme reverence of recognizing it as order, the reverse of all confusion. He knows that there is no incompatibility between simple and complex. He knows that each is arch enemy of disorder. And then he makes his drawing, his finite representation of an infinite subject, forest or single tree, in such a manner as shall declare glory of infinite creation by ordering his finite creation—no longer a camera-like copy, but rather an intelligent, affectionate shorthand record—by ordering his finite creation after that which is infinite. None save God and the poet deserve the name of creator, said Tasso.[2]

Languages may loose their meanings over time, particularly if they address a small, audience—or clan. Such specialized meaning and language, again verbal and visual, dies out when one no longer understands it. Marks, images, symbols, logos—call them what you will—that can stand the test of time are of value.

Some like the carving of the elk are clear in their inherent meaning and the story: no one stood in an obscure spot on a cliff, known only to others of the same clan, in blazing sun and chiseled away at a rock face for amusement. This was serious stuff that would benefit the "artist's" people for years to come.

At the same time, obscure abstract marks may continue to work on a different level—but only if their meaning lives on. The black and white diamond pattern that represents earth and sky to the denizens of Acoma Pueblo, New Mexico, literally represents the business re-engineering diagrams of a Cambridge, Massachusetts, software firm. One thousand years and languages apart, the same mark has two meanings. Both understand inherent qualities that relate to their story, their essence.

Identity, to the early inhabitants of this continent meant kinship and the bonds associated with kinship (essential for small nomadic clans), familiarity with a geographic area and its natural resources, and spiritual belief. The Fremont and

At top, nomadic clans would certainly recognize the elk with net. Below, general observers quickly see a stylized swan, moon, reeds, and the letter *S*, in this logo by David Kampa. A more specific audience recognizes the mark of the Shoreline Grill.

[1] A Note On Tree Drawing, *Art and Archeology*, Vol. III, No. 6, 1916, p. 347.

[2] Torquato Tasso, regarded as the greatest poet of the Italian High Renaissance, wrote lyric love poems and discourses on the art of poetry.

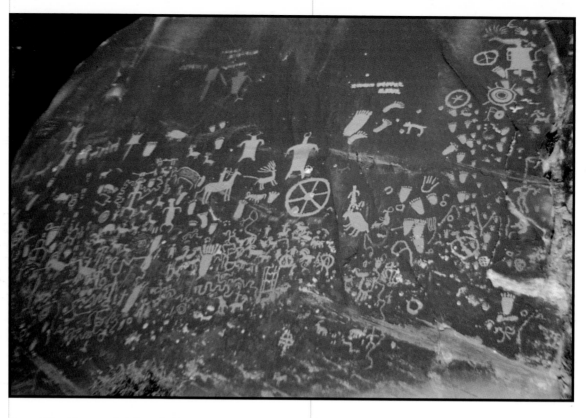

Newspaper Rock, in southeast Utah, contains marks ranging from the indecipherable Archaic Period, to historic representations of horse and rider . . . and the wheel.

Anasazi identities were as different as their visual languages, yet motifs were borrowed and assimilated, and certainly understood to a degree.

Each painstakingly pecked or painted image held within it a story, an idea, essential to the well-being of the clan. The stories may well have been accompanied by verbal explanations, which were transferred from generation to generation, but also had to serve as a system for presenting information to newcomers to the area. These shared stories held them together.

Within each tribe or clan there were designated specialists: hunters, gatherers, basketmakers, group leaders, spiritual leaders. And though anyone could pick up a rock and hammer on a cliff face, it was more often than not left to specialists. This responsibility fell to the shaman of the tribe, whose understanding of stories, lore, and myths, was as much a part of their everyday knowledge as was flora, fauna, and the stars. Theirs was a visual language, built upon the past, but meant for the future.

And as times changed, so too did the style of symbols, with more complicated levels of information necessitating innovation. The meandering lines of Archaic times, more a means of coding information, now generally lost in meaning, gave way

to clear images of hunters with atlatls, warriors with shields, and in historic times, riders on horseback. Risk became, not a matter of rendering images in difficult locations, not a matter of doing, but a matter of *not-doing*, of failing to act, of failing to communicate.

One thousand—give or take a few hundred—years later, from my perch on the third floor of a converted movie theater, I look out the window and see restaurants, nightclubs, office buildings, banks, and hotels. Pedestrians, tourists, people of every age, race, and religion each going about their daily business, and businesses of all kinds vying for their attention, marketing to them in their own self-image.

Hugh Dubberly, former design manager at Apple Computers, states, "If we took a survey of the steps people follow when starting a new business, we would probably find that creating a logo is in the top ten. From coffee shop to computer company, almost no self-respecting business goes to work without a logo."[3] These businesses each rely on specific languages to relate to their audiences.

Each area of commerce is, in and of itself, a culture. Clarity in defining their identity and conveying their unique message is paramount to the success and survival of all

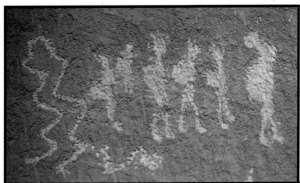

businesses. Those who can effectively communicate their identity in a superior fashion reap the benefits. "The identification of objects, brands, and corporate entities is a significant communication strategy in a consumer society,"[4] states Sharon Poggenpohl, educator, design practitioner, and editor of *Visible Language*. This is not to say that the well-designed identity and its follow through manifestations are a panacea to the marketplace. But long before financial analysts, market researchers, advertising account executives, public relations agents, business strategists, legal counselors, or product and service developers entered the picture, visual communication—graphic design—was part of the everyday rhyme and reason of trade and commerce.

Design (as a language of communication) is a component that has been part of every successful enterprise. Through the ages, languages both verbal and visual have been used to communicate messages from maker to the marketplace. While messages are as varied as makers and markets, clear content-driven communication, knows no equal.

Above, size and number give meaning—now lost—to these Fremont petroglyphs in Utah. At right, a contemporary symbol in New Hampshire warns motorists of backpackers on the road.

[3] Protecting Corporate Identity, *Communication Arts*, Jan/Feb 1995, p.14.

[4] Secondhand Culture, 1988, *Society of Typographic Arts Journal*, 1989, p. 47.

LOGOS, FLAGS, AND ESCUTCHEONS
PAUL RAND

Paul Rand's stature as one of the world's leading graphic designers is incontestable. For half a century his pioneering work in the field of advertising design and typography has exerted a profound influence on the design profession; he almost single-handedly transformed "commercial art" from a practice that catered to the lowest common denominator of taste to one that could assert its place among the fine arts.

Originally published in the American Institute of Graphic Arts, *Journal of Graphic Design*, Vol. 9, No. 3, 1991.

"IT REMINDS ME OF THE GEORGIA CHAIN GANG," quipped the IBM executive, when he first eyed the striped logo. When the Westinghouse insignia (1960) was first seen, it was greeted similarly with such gibes as "this looks like a pawnbroker's sign." How many exemplary works have gone down the drain because of such pedestrian fault-finding? Bad design is frequently the consequence of mindless dabbling, and the difficulty is not confined merely to the design of logos. This lack of understanding pervades all visual design.

There is no accounting for people's perceptions. Some see a logo, or anything else that's seeable, the way they see a Rorschach inkblot. Others look without seeing either the meaning or even the function of a logo. It is perhaps this sort of problem that prompted ABC TV to toy with the idea of "updating their logo" (1962). They realized the folly only after a market survey revealed high audience recognition. This is to say nothing of the intrinsic value of a well-established symbol. *When* a logo is designed is irrelevant; *quality*, not *vintage* nor *vanity*, is the determining factor.

There are as many reasons for designing a new logo, or updating an old one, as there are opinions. The belief that a new or updated design will be some kind of charm that will magically transform any business is not uncommon. A redesigned logo may have the advantage of implying something new, something improved—but this is short-lived if a company doesn't live up to its claims. Sometimes a logo is redesigned because it really needs redesigning—because it's ugly, old fashioned, or inappropriate. But many times, it is merely to feed someone's ego, to satisfy a CEO who doesn't wish to be linked with the past, or often because it's the thing to do.

Opposed to the idea of arbitrarily changing a logo, there's the "let's leave it alone" school—sometimes wise, more often superstitious, occasionally nostalgic or, at times, even trepidatious. Not long ago I offered to make some minor adjustments to the UPS (1961) logo. This offer was unceremoniously turned down, even though compensation played no role. If a design can be refined, without disturbing its image, it seems reasonable to do so. A logo, after all, is an instrument of pride and should be shown at its best.

If in the business of communications "image is king," the essence of this image, the logo, is a jewel in its crown.

Here's what a logo is and does:

A logo is a flag, a signature, an escutcheon.

A logo doesn't sell (directly), it *identifies*.

A logo is rarely a description of a business.

A logo derives its *meaning* from the quality of the thing it symbolizes, not the other way around.

A logo is *less* important than the product it signifies; what it means is more important than what it looks like.

A logo appears in many guises: a signature is a kind of logo, so is a flag. The French flag, for example, or the flag of Saudi Arabia, are aesthetically pleasing symbols. One happens to be pure geometry, the other a combination of Arabic script and an elegant saber—two diametrically opposed visual concepts; yet both function effectively. Their appeal, however, is more than a matter of aesthetics. In a battle, a flag can be a friend or foe. The ugliest flag is beautiful if it happens to be on your side. "Beauty," they say, "is in the eye of the beholder," in peace or in war, in flags or in logos. We all believe our flag the most beautiful; this tells us something about logos.

Should a logo be self-explanatory? It is only by association with a product, a service, a business, or a corporation that a logo takes on any real meaning. It derives it meaning and usefulness from the quality of that which it symbolizes, If a company is second rate, the logo will eventually be perceived as second rate. It is foolhardy to believe that a logo will do its job right off, before an audience has been properly conditioned. Only after it becomes familiar does a logo function as intended, and only when the product or service has been judged effective or ineffective, suitable or unsuitable, does it become truly representative.

Logos may also be designed to deceive; and deception assumes many forms, from imitating some peculiarity to outright copying. Design is a two-faced monster. One of the most benign symbols, the swastika, lost its place in the pantheon of the civilized when it was linked to evil, but its intrinsic quality remains indisputable. This explains the tenacity of good design.

The role of the logo is to point, to designate—in as simple a manner as possible. A design that is complex, like a fussy illustration or an arcane abstraction, harbors a self-destruct mechanism. Simple ideas, as well as simple designs are, ironically the products of circuitous mental purposes. Simplicity is difficult to achieve, yet worth the effort.

The effectiveness of a logo depends on:

A. distinctiveness

B. visibility

C. useability

D. memorability

E. universality

F. durability

G. timelessness

Most of us believe that the subject matter of a logo depends on the kind of business or service involved. Who is the audience? How is it marketed? What is the media? These are some of the considerations. An animal might suit one category, at the same time that it would be anathema in another. Numerals are possible candidates: 747, 7-Up, 7-11, and so are letters, which are not only possible but most common. However, the subject matter of a logo is of relatively little importance; nor, it seems, does appropriateness always play a significant role. This does not imply that appropriateness is undesirable. It merely indicates that a one-on-one relationship, between a symbol and what is symbolized, is very often impossible to achieve and, under certain conditions, may even be objectionable. Ultimately, the only thing mandatory, it seems, is that a logo be attractive, reproducible in one color, and in exceedingly small sizes.

The Mercedes symbol, for example, has nothing to do with automobiles; yet it is a great symbol, not because its design is great, but because it stands for a great product. The same can be said about apples and computers. Few people realize that a bat is the symbol of authenticity for Bacardi Rum; yet Bacardi is still being imbibed. Lacoste sportswear, for example, has nothing to do with alligators (or crocodiles), and yet the little green reptile is a memorable and profitable symbol. What makes the Rolls Royce emblem so distinguished is not its design (which is commonplace), but the quality of the automobile for which it stands. Similarly, the signature of George Washington is distinguished not only for its calligraphy, but because Washington was Washington. Who cares how badly the signature is scribbled on a check, if the check doesn't bounce? Likes or dislikes should play no part in the problem of identification; nor should they have anything to do with approval or disapproval. Utopia!

All this seems to imply that good design is superfluous. Design, good or bad, is a vehicle of memory. Good design adds value of some kind and, incidentally, could be sheer pleasure; it respects the viewer—his sensibilities—and rewards the entrepreneur. It is easier to remember a well designed image than one that is muddled. A well designed logo, in the end, is a reflection of the business it symbolizes. It connotes a thoughtful and purposeful enterprise, and mirrors the quality of its products and services. It is good public relations—a harbinger of good will

It says "We care."

CORPORATE

CLIENT
Digital Equipment Corporation
Maynard, Massachusetts

CLIENT CONTACT
Jean Bouchenoire, Director of
 Brand Management
Eileen Palmer, Brand Identity Manager

DESIGN FIRM
Sametz Blackstone Associates
Boston, Massachusetts

CREATIVE DIRECTOR
Roger Sametz

LEAD DESIGNER
Bob Beerman

DESIGNERS
Tim Blackburn, Hania Khuri,
Cindy Steinberg

PRODUCTION MANAGER
Michael Eads

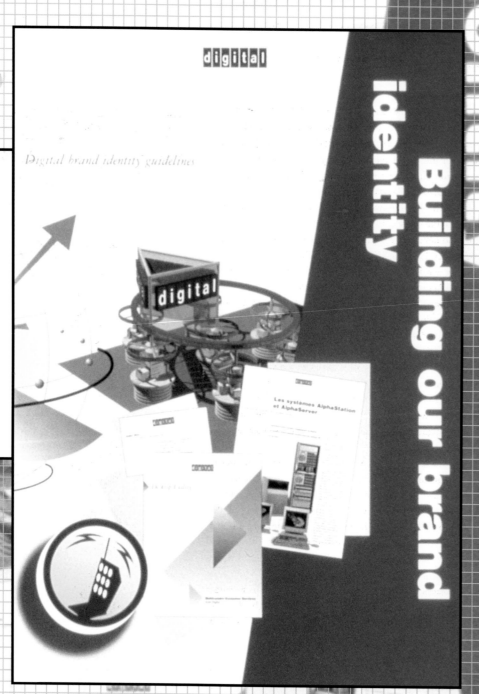

DIGITAL EQUIPMENT CORPORATION
SAMETZ BLACKSTONE ASSOCIATES

A Principles-Based Communications System to Establish a Global Brand

THE BUSINESS ARENA CONTINUES TO CHANGE. Not only is there often more competition, but approaches to marketing have become increasingly sophisticated and market segments more demanding. All this, while the product cycles that these marketing efforts support continue to grow shorter, especially in the information technology industry. For the thirty-five-year-old Digital Equipment Corporation, historically makers of high-technology hardware and software—but now purveyors of integrated, networked, cross-platform solutions—it was time for re-evaluation and change.

Until recently, Digital had never put resources behind building a Digital brand; they concentrated on product development. With that approach, there was no underlying common design strategy across the company, with little connection between one product line and the next. Research showed their brand value was nowhere near the level of their competitors, and in terms of dollars expended on promotional materials and advertising (also product-focused), the payoff was low.

Management realized they had a problem. By focusing on product, Digital had not been creating value for the Digital brand. While any given product might be a success, the excitement surrounding it never linked to the Digital brand. And when a product cycle neared its end, there was little residual equity for the company. Further, research showed that a strong brand can command a higher price and increased loyalty from customers. With growth and profit resting on the success of individual products, alone, not higher-level brand allegiance, this was a strategy the company could no longer pursue.

Sametz Blackstone Associates was brought in to work with the newly created Office of Brand Management. The group had the task of developing and implementing a strategy to build a globally-recognizable Digital brand. Sametz Blackstone was provided with research on corporate attributes that showed the company needed to be easier to do business with, needed to be more outward- and customer-focused, needed to be more focused on technology as enabling solutions—not technology for technology's sake. And the company needed to be more energized!

Simultaneously, Sametz Blackstone was retained to develop a new, more rational architecture/hierarchy for promotional literature. They determined what kind of promotional pieces should be created, for whom, with what production values, and most importantly, how a modular system of pieces could be leveraged to support different points in the sales cycle—at lower cost.

There was also research around promotional materials. They were not as effective as they needed to be, and judged not top-tier. Often written for the wrong

Key to the program is combining what Digital already owns (its logo and color) with focused approaches to writing, design, typography, color and imagery. Working together, these approaches make materials uniquely "Digital".

The brochure was prepared for the broadest of audiences: those who commission, evaluate, produce or pay for communications.

Seen on this page, Digital's "bright" palette, highlight yellow, and background tan. All are given their CMYK equivilents.

Opposite page, *Building Our Brand Identity*, is a step-by-step overview of the principles of the Digital identity, covering aspects of writing style, color, typography, photo and logo usage, and layout style.

audience (enterprise benefits to some-one interested in specs; speeds and feeds written to CIOs), and with little shared look and feel, it was difficult to assemble a package that supported either solution-selling or one that gave a clear picture of who Digital was and what it stood for.

There were also operational issues. A new branding and promotional literature system had to be effective across business units and across oceans. It had to take into account there were fewer communications professionals at the company and that two-hundred vendors around the world would be the actual implementers of the program. A new program needed to match this decentralized model, save time and money, and make a rational connection between production values and revenue opportunities.

A system without creative opportunity, shoved down vendors' collective throats, would result in failure. Further, the company had recently been reorganized into autonomous business units. A system needed to be designed that people would want to embrace, as there was no top-down imperative for them to do so.

Sametz Blackstone developed a new model—one based on principles, not rules; approaches not recipes. Only such a system could, they felt, possess the flexibility to respond to the different needs of geographies, businesses, and communications disciplines—and still have enough "glue" to create a recognizable look and feel around the world.

So, rather than creating a system loaded with compulsory do's and don'ts, Sametz produced a system that promoted thinking. They developed

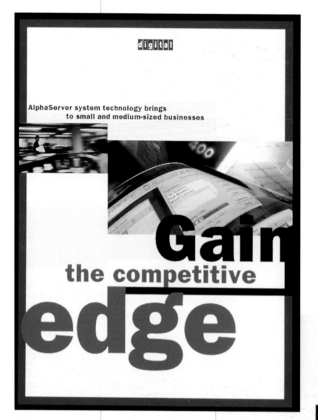

Hardworking, readable, and engaging typography creates a hierarchy of information that treats text in a consistent manner. Because most Digital customers are overwhelmed with information, signposts are given to the reader to help him or her navigate the materials, finding information quickly.

Second generation publications, seen on these pages with burgundy borders, take the bold use of typography another step forward—and continue to reinforce Digital burgundy.

Giving **developers** the tools to build better applications

You know exactly what you're looking for in your development process: Smooth predictability... and cost-efficiency... and of course, the ability to manage umpteen revisions. To assure you'll have the applications you need, look to Digital's Alpha systems.

The face of wrinkles

COHESIONworX™ offers the ability to combine networks of UNIX-based development systems with Windows NT systems.

Digital UNIX: The 64-bit solution

COHESION SEE: A world-wide software alliance

digital

DIGITAL Personal Workstations

DIGITAL's workstation family—the fastest UNIX and Windows NT workstations on the planet

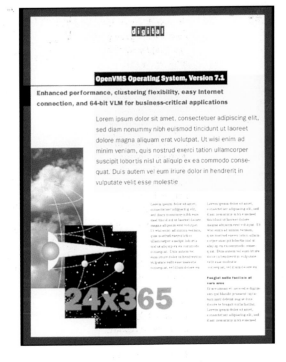

digital

OpenVMS Operating System, Version 7.1

Enhanced performance, clustering flexibility, easy Internet connection, and 64-bit VLM for business-critical applications

building blocks, not prescriptions. These building blocks could then be applied to different media and different opportunities, as appropriate. But the result would still be distinctly Digital.

The system comprises three major components:

1 Elements that Digital owned: its logo, color, business partner marks

2 Focused approaches to writing, design, typography, color, and imagery

3 Awareness and tactical training at all levels to build consistency over time.

In place of a dusty standards manual Sametz Blackstone created an interactive web site so the most recent information and templates could be distributed worldwide—making it easier for people to get on board, quickly.

The working group consisted of Sametz Blackstone and two groups within Digital. The first included horizontal representation from the different business units. The second, a vertical representation from the different communication disciplines—event graphics, promotional literature, facility signage, etcetera.

After the investigative phase, the design team visited six business units. According to Sametz, "Much as we were trying to get communications professionals to speak the language of their customers, we spoke the language of ours. We never talked about design. We showed our audiences that they could have materials that were more effective, spoke more directly to their audiences, were more easily translated, were more acceptable cross-culturally, incorporated the needs of business partners and new selling channels, could be done more easily. Oh yes, they also

Design:

Product and Process

"TYPICALLY DESIGNERS ARE brought in too late and leave too early," states Sametz, "What they do is iterate, make things. On the front end, they are often not in on the strategy, the planning, on bringing [the right] people together. On the far end, they are not in on 'how will this thing live on after I'm gone'. They do not help the client to become more self-sufficient. Design can do much more."

Sametz is right on target. His firm has spent two decades creating and implementing strategic communications and building brands. Over that course of time he has had the opportunity to work with a large number of clients. "It's like a very different MBA program," says Sametz. This "education" becomes a benefit to the next client, where although business problems may vary, "the assessment of needs, goals, personalities, resources, and audiences is always critical not only to make the most compelling communications—visually—but to make communications that will really work hard on the client's behalf."

Sametz works with his clients to first define a program—so that all work is then judged against what the group agreed to achieve. According to Sametz, "This moves any project from the level of 'I like it / I don't like it' to the more useful level: it works or it doesn't." If a program and process are "designed", in addition to specific communications, design can effect significant change.

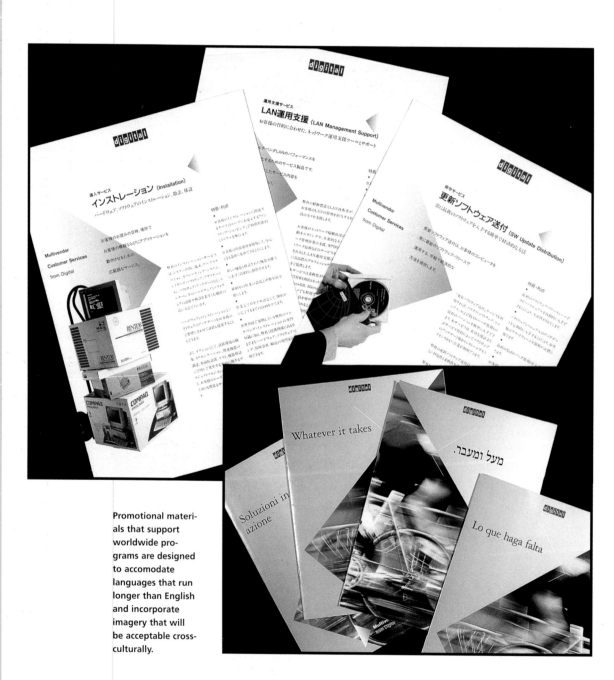

Promotional materials that support worldwide programs are designed to accomodate languages that run longer than English and incorporate imagery that will be acceptable cross-culturally.

looked a lot better and supported a single brand, but that wasn't the sell."

One small example shows the payoff of this strategy. Seven high-level image pieces had been created one-off for the Multivendor Customer Service division, each in a different country at considerable cost, Working with a small international client group, Sametz was able to produce a single piece that was locally translated and printed in the same seven countries. (The imagery even works when flopped in the Hebrew version.) The payoff: savings that equalled the cost of five brochures and a big step toward creating a global brand.

The development and implementation of Digital's branding strategy is now in a second, evolutionary phase. This next generation relies on the same principles, but even items like data sheets are benefiting from punchier, more articulated typography and an increased emphasis on Digital burgundy.

Brand awareness is increasing. Business units that were not required to be on board, are. Vendors have a system they can work with. And a consistent look and feel to support a unified brand image is emerging.

"The story is not so much about design the way we usually think about it," says Sametz. "It's about process, and about making communications effect change. About making it global. About getting people on board and invested in the product and the process—those who commission and those who make." Sametz believes this project—and more importantly its process—"demonstrates that design can truly be strategic; it's not cake icing."

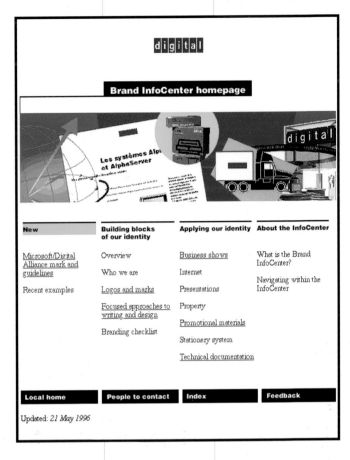

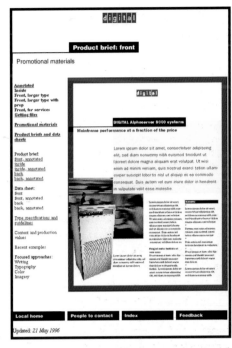

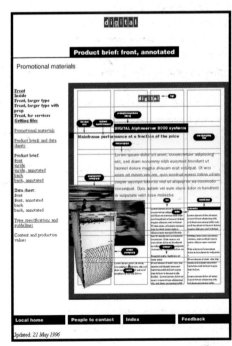

The Brand Info Center, Digital's password-protected brand site, is the perfect teaching vehicle. Designers anywhere in the world can both find out about the thinking around the Building blocks and download templates for a data sheet or a variety of other publications, each complete with grid, type and color palettes. Both US and A4 templates are available, for PC and for the Mac.

The Brand Info Center is emblematic of this new, principles-based system. Vendors are given the *why's* before the *how's*— then given the tools and the creative headroom to build successful communications.

KANSAS CITY, MISSOURI
EAT, INCORPORATED

Pro Bono Publico for the "Heart" of the Nation

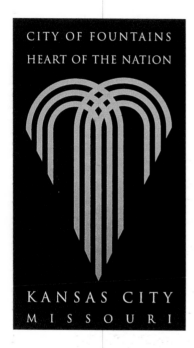

AFTER A YEAR OF COLLECTING logo ideas from a variety of area professionals, schools and artists, volunteer committee chair Octavio Viveros was stumped. Submissions met neither the committee's nor the mayor's criteria for an identity that embraced the image of a progressive and fast-growing center of commerce, in the heartland of the United States.

By chance, Viveros was in the market for a new identity for his law firm and reviewed the portfolio of EAT, Incorporated. Liking what he saw, he asked principal Patrice Eilts-Jobe if she would submit sketches for the city's logo search. The answer was yes, but only on condition that the competition was ended and her firm were contracted for the project. The point was clearly made that one gets what one pays for. Competitions may seem like a good idea to those offering them, but if the end results need to meet a certain level of quality, it's best not to leave the achievement of that goal to arbitrary factors. On that basis EAT, Inc. would perform the work *pro bono publico*—for the public good.

As the largest city closest to the nation's geographic center, Kansas City has long been known as the "heart" of the United States. Second only to Rome, Kansas City boasts more fountains than any other city in the world. The final mark is a successful and graceful combination of two of Kansas City's most celebrated attributes.

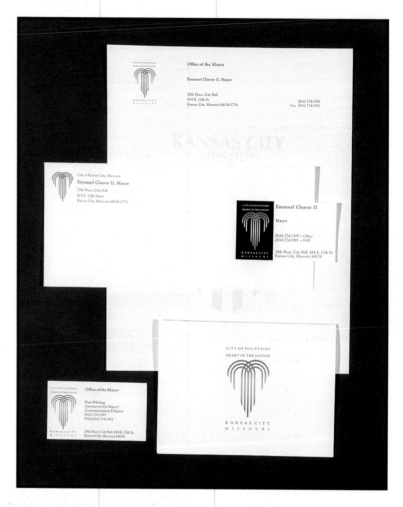

CLIENT
Office of the Mayor
Kansas City, Missouri

CLIENT CONTACT
Emmanual Cleaver II, Mayor
Octavio Viveros, Counsel

DESIGN FIRM
EAT, Incorporated
Kansas City, Missouri

ART DIRECTOR
Patrice Eilts-Jobe

DESIGNER
Patrice Eilts-Jobe

Fourteen sketches were provided to the committee for selection. The one chosen was the version which, when first doodled at 3/4 inch (2 cm), designer Eilts-Jobe intuitively knew to be the best.

All-caps Goudy Oldstyle creates a monumental feel and provides a typeface readily available for any number of government offices.

A palette of 100 percent cyan, magenta, and black is intended to keep the printing process simple for all concerned parties.

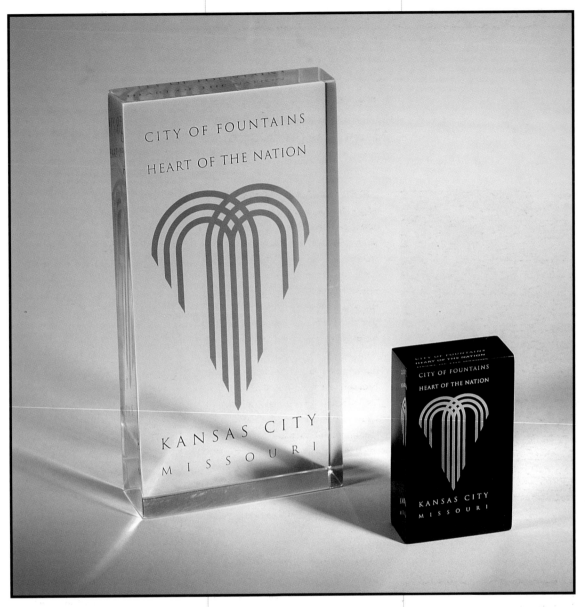

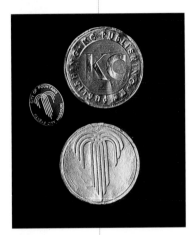

Above, the lapel pin reads "City of Fountains," as Kansas City is known.

Also shown are promotional chocolate coins for KC Publishing, a division of city offices.

After establishing the legalities of copyrights (color palette, typeface, etc.), the city began its initial applications. To completely replace all materials with the new identity would cost almost half a million dollars. The city, like any corporation implementing such a system, will slowly phase in the new mark.

Ironically, the first iteration that designer Eilts-Jobe saw in use was on a bench warrant issued for her arrest for failure to pay a parking ticket. She promptly paid.

Seen above are prototypes for *Key to the City* awards.

INFAB

WAGES DESIGN

Critical Timeframe = Right the First Time

A loosely kerned Frutiger Light was used for the logo. Text in the same face is set with negative kerning and solid leading, according to the parent company's specs.

THERE ARE OFTEN SEVERAL reasons for the time it takes to roll out an identity program. In the case of Infab, a multibillion-dollar consortium of three worldwide leaders in semiconductor manufacturing and automation, a major trade show deadline became a driving force in turnaround time.

In panic mode, Infab called on Wages Design and asked for a meeting the next day. It was critical for Infab, essentially a start-up sector of the consortium, to project a strong corporate image. Their target clients include some of the major players in the microchip industry.

Wages, a seasoned designer, returned after the weekend and presented one logo for consideration. Electronic transmission of layouts and copy supplemented meetings in Atlanta and Austin. Within six weeks an entire identity system had been produced: logo, letterhead, trade show panels, and introductory trade advertising. Collateral materials came off press in Atlanta the morning of the trade show and arrived in Austin later that day.

A year later, the successful Infab consortium became a wholly-owned subsidiary of Jenoptik, one of the members of the original consortium. Wages Design is now working with Jenoptik Infab and has modified the "Infab" look, utilizing the corporate color scheme of the parent organization.

CLIENT
Infab | Austin, Texas
Jenoptik | Jena, Germany

CLIENT CONTACT
Jim Holliday, President, Infab
Andrea Schön, Assistant to
General Manager, Jenoptik

DESIGN FIRM
Wages Design
Atlanta, Georgia

ART DIRECTOR
Bob Wages

SENIOR DESIGNER
Rory Myers

PROJECT MANAGER
Sandi Corey

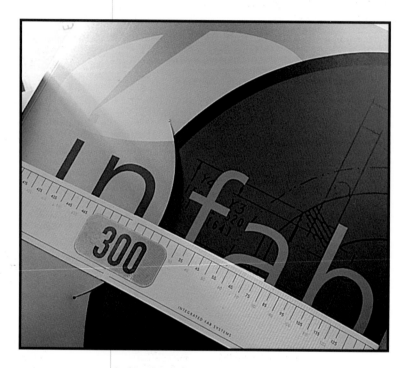

The logo for Infab, seen here on a pocket folder, represents a focus on a microchip functioning as the "dot" on the "I" in Infab; it also uses the wafer as a graphic element.

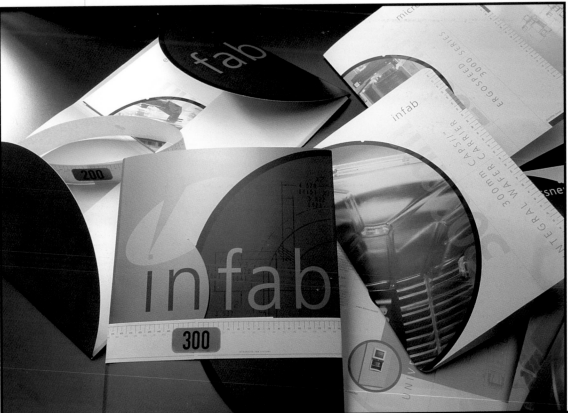

To reinforce the analytic, scientific look, a ruled waistband indicating either the 200 or 300 mm wafer size, is used. Semicircular flaps on the pocketfolder again refer to the microchips.

Black-and-white photography is printed on a matte paper in duotones and tritones with metallic ink, referring to the metallic quality of the wafers.

The Infab brochure and product sheets provide information on the consortium and technical information on each product line.

At right, circles showing the actual size of the wafers are used as the design theme to emphatically reinforce Infab's capabilities. They reflect the new technology of 300 mm wafers, as opposed to the older 200 mm size.

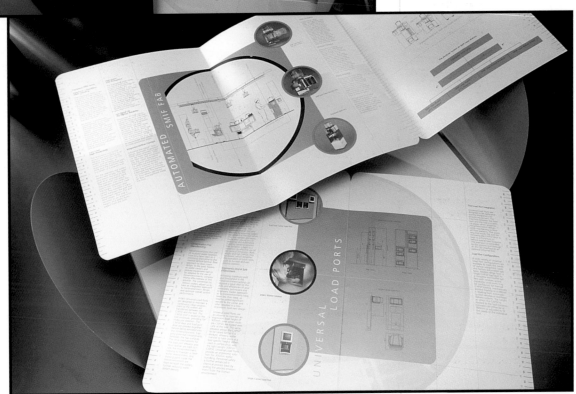

THE EDMOND-HOWARD NETWORK
plus design inc.

Above and right, initial sketches set out to prove the point that an identity is more than a logo. As the embodiment of an idea or purpose, the visual identity must quickly convey the attributes of a given enterprise, as seen in these simple, yet thoughtful iterations.

CLIENT
The Edmond-Howard Network
Roswell, Georgia

CLIENT CONTACT
Edmond Legum, President

DESIGN FIRM
plus design inc.
Boston, Massachusetts

ART DIRECTOR
Anita Meyer

DESIGNER
Anita Meyer

Visual Manifestation
of an Idea

IN THE PROCESS OF DEFINING both his consultancy and the role it plays within the wireless communications industry, President Edmond Legum sought out a design studio to define their new identity. As an avowed typography and design fan, Legum turned to the American Center for Design's *100 Show* annual to solicit potential firms. Of the seventeen to whom he wrote, three responded. After studying the submitted proposals, he chose plus design.

The intended goal of The Edmond-Howard Network is to become the preferred choice for total sales and management consulting in the wireless communications industry by providing its clients with a working knowledge of this industry.

The first step in the creative process began with the research and development of a design and marketing brief. The prospectus summarized the company's background, growth potential, target markets, and offered services. Legum and designer Anita Meyer outlined conceptual issues and criteria, as well as the potential scope of projects. One idea generated during the research phase proposed that Legum write a book for marketing, promotion, and client education. It is in the works.

The final identity system embodies the concepts of reference books and knowledge and definitively positions The Edmond-Howard Network as the source to turn to within the wireless industry.

Collaboration became an easy part of the process for plus design when they found themselves working with a client who understood quality design. The client's suggestion of the seldom-seen Eric Gill typeface Aries was complemented by the addition of contemporary sans-serif fonts Isonorm Mono (as a secondary face) and Officina Sans for use on correspondence.

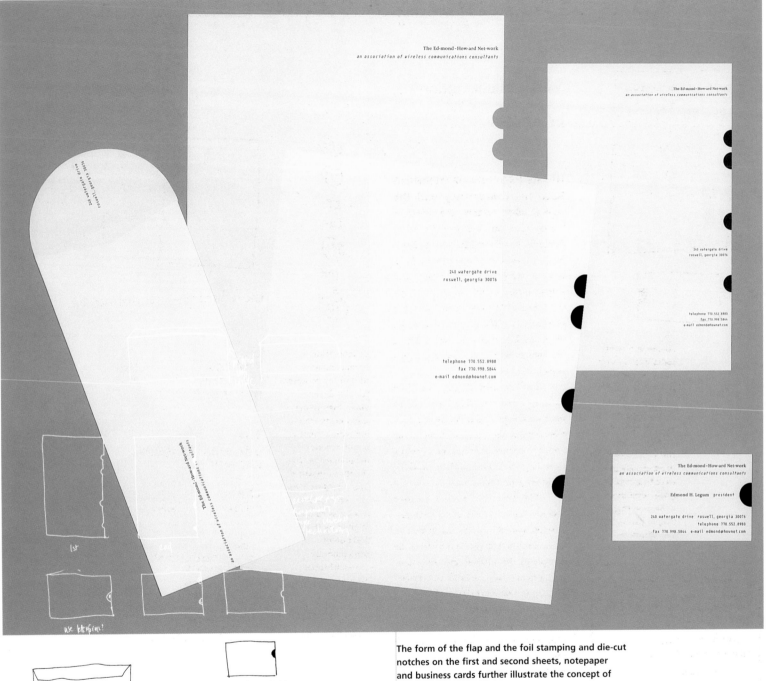

reference to idea only

The form of the flap and the foil stamping and die-cut notches on the first and second sheets, notepaper and business cards further illustrate the concept of reference books. The flexibility of the design strategy allows for future design applications in response to company growth. In the end, the identity achieves an air of erudition, authenticity, and authority.

INTELSAT

GRAFFITO/ACTIVE8

Transmitting Images to
Inform, Excite, Entertain

A custom font and
updated references
to satellites and
Earth stations com-
plete the new logo.

**THE EARTH'S POPULATION DRAWS
closer on a daily basis as
news and entertainment is**
is broadcast to all corners of the world
in a continuous stream of information.
Yet even the firms that transmit these
messages must first transmit their own
message. On the basis of a cold call and
the strength of their portfolio,
Graffito/Active8 was commissioned to
produce an annual report for satellite
telecommunications firm, Intelsat.

Intelsat is an international satellite
service, and the annual report serves as a
synopsis to their signatories (different
member countries). The design and con-
tent focused on major events broadcast
to the global village by Intelsat's satellite
service. Highlighted were such triumphs
as the Olympic Games and the fall of the
Berlin Wall, as well as the company's own
Reboost mission (Intelsat had a satellite
falling out of orbit and had to coordinate
with NASA to "reboost" it into orbit). In
short, the report demonstrated how
Intelsat unites the world.

After the annual's successful
reception, Graffito/Active8 was asked to
redress the firm's identity and roll out
new collateral materials. The plan, artic-
ulating the new director general's vision
and mission statement, prepares the
company for competing well into the
twenty-first century.

New materials include sales sheets,
direct mail, lapel pins, and a series of
brochures, all projecting an image of for-
ward-thinking sophistication.

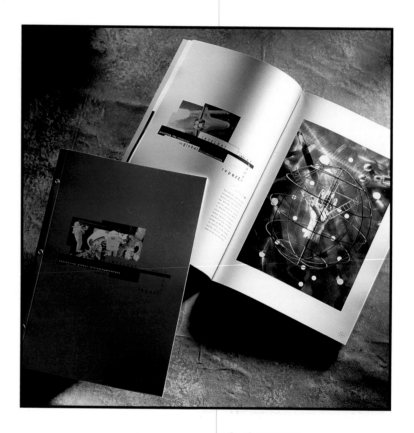

In the above report,
Neleman's photo
constructions are
supported by client-
supplied photos,
which have been
treated with a
number of printing
techniques and
imaginative crop-
ping. A riveted
spine and metallic
inks throughout
add an element
of "hardware."

CLIENT
Intelsat
Washington, D.C.

CLIENT CONTACT
Tony Trujillo, Director of Marketing

DESIGN FIRM
Graffito/Active8
Baltimore, Maryland

CREATIVE DIRECTOR
Tim Thompson

DESIGNERS
Tim Thompson, Joe Parisi,
Dave Plunkert

PHOTOGRAPHERS
Hans Neleman, client supplied

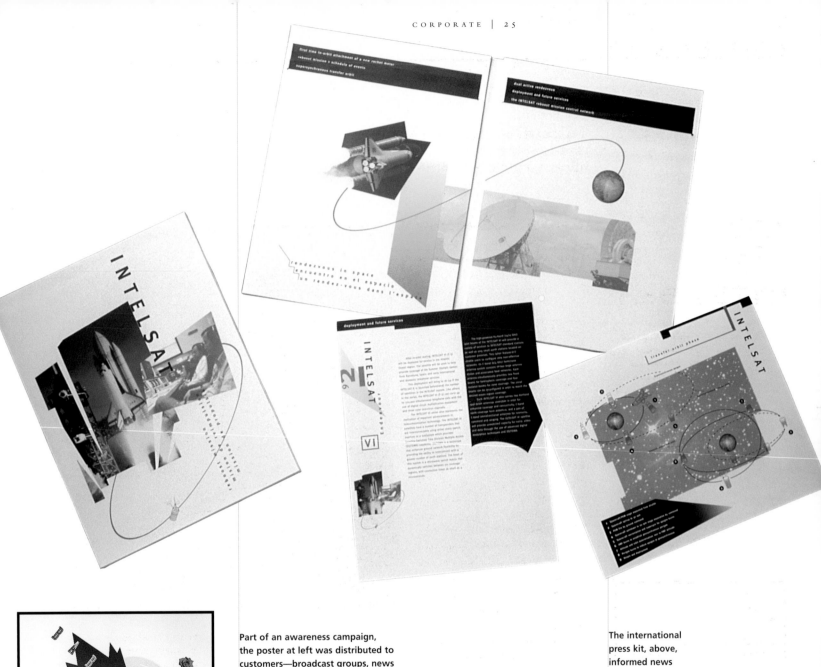

Part of an awareness campaign, the poster at left was distributed to customers—broadcast groups, news agencies, etc.—promoting the live broadcast, *via Intelsat*, of the 1992 Olympics. Also produced as a limited edition silkscreen, the poster is a balance of art and utility, short on copy, long on style.

The international press kit, above, informed news groups of a monumental mission between NASA and Intelsat. It uses a fluid grid design to incorporate varying lengths of three different languages. The annual reports use the same technique.

ENTERTAINMENT

CLIENT
fX
Fox Broadcasting

DESIGN FIRM
Corey & Company: Designers, Inc.
Hatmaker
Big Blue Dot
Watertown, MA

PROJECT DIRECTORS
Scott Nash, Tom Corey

DESIGNERS
Tim Nihoff, Mark Schroder,
Al Venditto

PROJECT MANAGER
Mary Beth Johnson

PRODUCER
Miriam Tendler

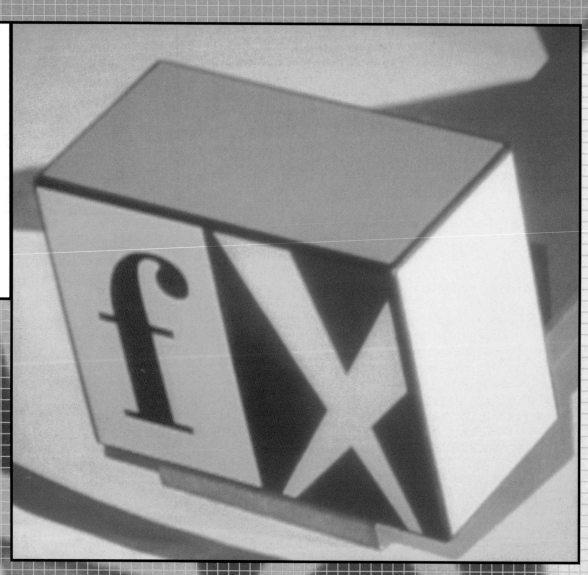

fX CABLE NETWORK
BIG BLUE DOT

A Unique Combination of Positioning and Design

SINCE THE EARLY DAYS OF THE FILM INDUSTRY, only a few major players have managed to stake a claim and hold on to it in this highly competitive business. Hollywood has been built on perception, rather than reality, and while there are many factors that contibute to the rise and fall of studios, their images—and identity—remain long after the closing credits. Think of MGM, and not only does one picture a lion, but one also imagines its roar. Paramount brings to mind a bucolic snow-capped peak; Universal through the years has shown a variety of spinning globes; and Columbia Pictures recently refined and updated its flowing-robed feminine personification of the United States. From the onset, the audience is led to expect a certain quality as epitomized in these famous trademarks.

Twentieth Century Fox also ranks as one of the aforementioned studios whose aura is brought to life by a powerful identity. It is easy to recall the monumental letterforms awash in kleig lights, as seen from the vantage point of the lower right corner.

Yet vantage points change, and over the years major studios have, by necessity, found themselves expanding their vision as new arenas of entertainment have developed. During the past decade, one of the fastest-growing arenas has been cable television.

Without going into the Byzantine world of broadcast regulations, suffice it to say, Twentieth Century Fox saw an opportunity and an audience in cable, and took it. In the process it created one of the largest cable launches in broadcast history.

The new president of Fox, Anne Sweeney, previously served at the cable network Nickelodeon. It was there she became aware of Corey & Company: Designers, Inc., although they didn't have the chance to work together. In 1988, Tom Corey and his associates developed the Nickelodeon identity and have subsequently worked on a variety of projects for the network. When Sweeney joined Fox, a call went out to Corey & Company to help in the overall strategic thinking and positioning of the new venture.

Through years of plying their trade, Corey & Company—and their ancillary studio divisions Hatmaker, which focuses on broadcast work, and Big Blue Dot, which focuses on development of child-related projects—have become known as the consultant design studio best suited for strategic positioning within the broadcast industry. According to Partner Scott Nash, the Watertown, Massachusetts-based firm was "in the right place at the right time in the mid-1980s. We had projects that any self-respecting Boston studio would want—real estate, college, health care. But we had an interest in entertainment." With a pointed marketing plan they soon found themselves creating custom alphabets for MTV, which led to work for Nickelodeon,

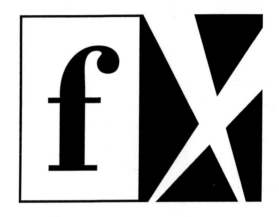

Designer Tom Corey felt he'd struck paydirt on an early iteration of the logo (left), initially approved by the client. But when both got cold feet, he tried further adaptations (below) before he and the client returned to the original version.

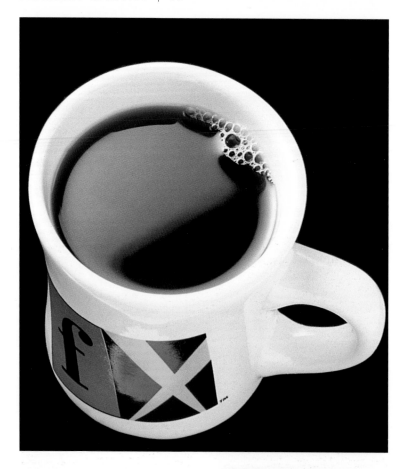

which led to work for TNT, which led to work for the BBC, and so on.

What Corey found was that his firm was soon applying traditional design and identity concepts to networks, which had previously looked to producers and programmers for their vision. With their insight into the industry and Corey's strength as a writer, they have moved beyond the realm of a traditional design studio and are frequently called in for consulting on projects.

Corey points out that his firm was in the unique position of coming on board the project before programming started. Working with a committee that included Sweeny, acquisition and new programming directors, sales executives, branding and marketing consultants, Big Blue Dot set out to draft a twenty-page positioning paper. The paper spelled out and supported a paragraph's worth of mission statement and, in the process, identified the tone and character of the new network. This initial positioning statement helped establish the essential ideas that would inform all future creative directions, decisions, and even programming.

Apparent almost from the beginning was the sense that the new channel be considered "television made fresh, daily" by bringing a live quality to a cable network. This approach harks back to the early days of television when, though programming was planned in advance, it was still broadcast live. As Tom calls it, "shooting from the hip."

"Hip," as defined by Webster, means cognizant, comprehending, a certain connectedness. Early in the planning stages, connecting with people—with viewers—became a key theme for the project. This notion

Undoubtedly the best way to experience the fX identity is by watching the cable network on television. However, the natural demands of sales and marketing require the more traditional uses of promotional items to continually reinforce a dynamic identity.

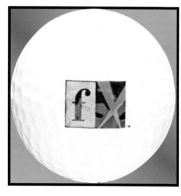

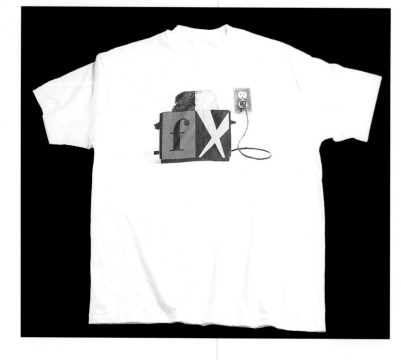

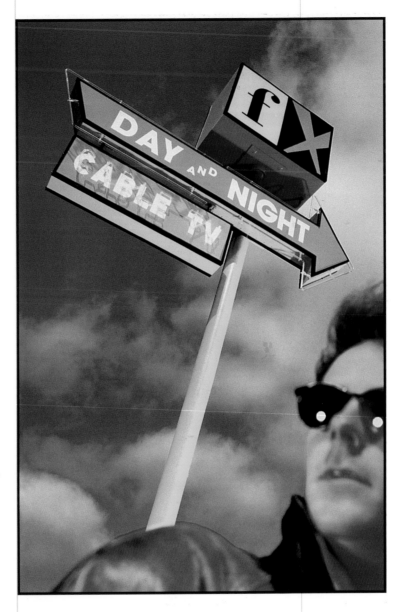

led to a decision to use photography and live action film as an integral part of the new identity. These media, according to Nash, are "much more seamless . . . [people] take it for granted." This approach stands in contrast to the many varieties of animation used by competing networks. However rendered, animation lacks the warmth of photography and, even more importantly, does not provide a sense of "place." This idea of "place" would soon manifest itself in the development of the logo.

Of course, before developing a logo, there must be a name. When Big Blue Dot was brought on board, a name for the novice channel had yet to be announced. Though the new channel had no identity, its parent company Twenty-first (born Twentieth) Century Fox had a commanding public presence. Surveys soon showed that potential viewers were averse to calling the cable channel "Fox," but felt there should be some connection, as equity in the parent company was so strong.

That left Big Blue Dot in the spot of creating the new moniker. While they came up with many names, fX became the firm's favorite. As Corey wrote in a preliminary paper, "I think this is my favorite. It has a hip, entertainment industry flavor to it, and it's an obvious reference to Fox. I'm very excited about the the design possibilities—they are two cool letters that fit nicely with each other."

With that said, Corey soon created the logo and, in an unprecedented move for the firm, faxed that sole version to the client along with their cries of "Eureka." The client and design firm soon got cold feet, and Corey

and company spent more time working on further iterations. None were as compelling as the first, however, and it is clear why they soon returned to the original version.

The mark is designed with a television ratio (height and width both proportionate), and the letterforms are then separated. The *f* feels at once classic by making use of a Bodoni letterform and friendly by using the lowercase version. In turn, the strongest

The client owns an extensive collection of constructed logos, in a multitude of sizes. These are used in all manner of promotional venues, as shown in this poster.

Time to watch the fX channel.

part is the letter *X*. Rendered in asymmetrical white-on-black forms that taper from top to bottom, the skewed *X* is snugly confined to a box. While the contrast between the classic *f* and the funky *X* is refreshing, it is the *X*'s reference to the original Twentieth Century Fox kleig lights that bring everything together within the mark.

The client approved of the mark, yet with all the discussion about "connecting with people in a real place," a committee member wondered why the studio was presenting the logo in such a flat manner. Corey makes it sound like the conference room was filled with the sound of beavers slapping their collective tails against the water in alarm, as he and Nash slapped their own foreheads and uttered "of course!" That led to the instrumental idea of the logo as object and existing in real space—in a specific environment. The client now has a collection of various-sized logo boxes for their many promotional spots.

Corey and Nash are quick to point out that the logo alone does not make the fX identity. As Corey neatly puts it, "the logo is the grain of sand in the center of the pearl. It is part of the identity." And Nash, a finger-pickin' Dobro player, adds that music and sound play as key a role in the network's friendly identity as do consistent typography and bright, saturated color.

Within a year Big Blue Dot completed positioning, identity, first passes at consumer and trade advertising, and applications such as necessary collateral elements, marketing materials, the news set, and a style guide. As the components are put in place for the client to maintain the identity, "We work ourselves out of a job," Corey adds, "with a system that works."

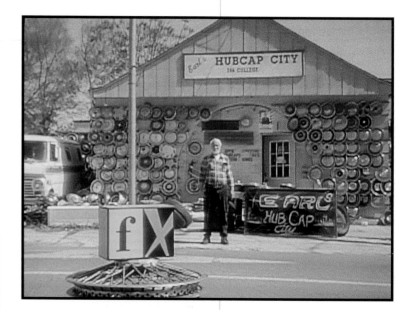

Early collage and illustrated marker comps, above and left, for promotional materials show the fX logo in several contexts: beach towels, adhesive bandage, salt and pepper shakers, and beverage coolers. The final projects used photography, not illustration.

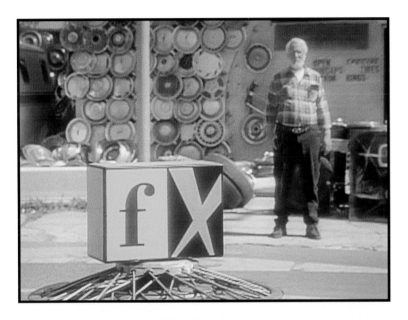

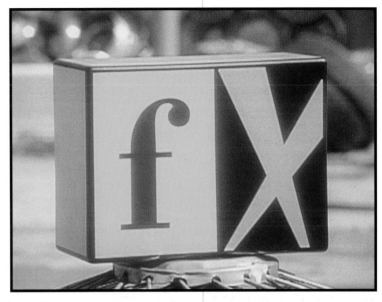

The logo becomes a real object and is placed in a variety of environments by using photography and film to create a seamless blending of identity and "place."

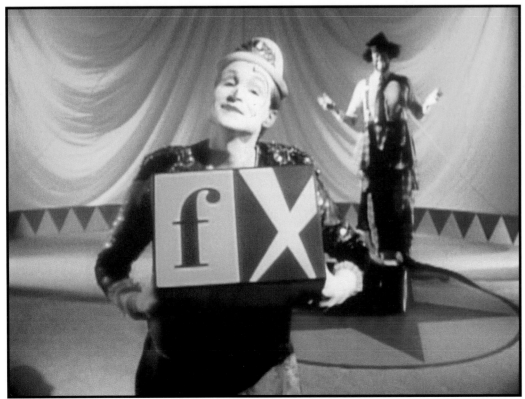

S P O T D E S I G N

Cross-Marketing
and a New Approach

**MOST SUCCESSFUL VENTURES
have made use of equal
amounts of risk and innovation.**
Entertainment mogul David Geffen
initially was excited about producing the
album for the theatrical production, *Rent*,
after viewing its early off-off-Broadway
iteration. He perceived that if the show was
marketed correctly from the start, he
would have a better chance of producing a
recording that would appeal to a wider
audience than a traditional cast album. And
any advantage for the recording would
turn out to be an asset for the show as a
whole. Cross-over potential could only be
achieved by thinking outside the parame-
ters of traditional Broadway productions,
by marketing it as an event, not as just
another Broadway show.

Spot Design had worked with
Geffen Records for a number of years on
both advertising and albums. After Spot
saw the show, they produced a marketing
memo to describe their thoughts and make
sure they agreed with the producers about
the defined goals. Spot felt that by being
too specific in the graphic approach (that
is, metaphor as solution), they would not
reach a large part of the potential audience.
The evocative solution rests in images that
capture the spirit and emotions of the
performers.

With keen marketing and design,
three million dollars worth of tickets sold in
the three days after initial advertising hit,
financiers of the show saw a return on their
investment in a record three months, the
fastest payback in Broadway history.

Cutting through the
clutter of other
Broadway graphics,
stencils and a bit of
black tape achieve
the low-budget
look. The text uses
Trixie, an abused
"typewriter" font.

CLIENT
Dreamworks Records
Los Angeles, California

CLIENT CONTACT
Robin Sloane, Creative Director

PRODUCERS
Jeffrey Seller, Kevin McCallum,
Alan Gordon

DESIGN FIRM
Spot Design
New York, New York

ART DIRECTOR
Drew Hodges

DESIGNERS
Drew Hodges, Naomi Mizusaki

PHOTOGRAPHER
Amy Guip

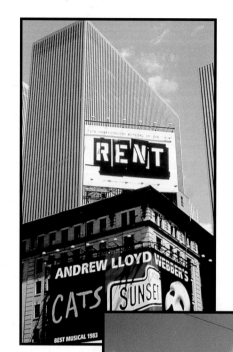

Early on, producers
hoped to capture
what they consid-
ered the "grunge
rock" element of
this story, which
takes place in
Manhattan's East
Village. Spot
Design pointed
out that the perfor-
mance was more
about theater, and
the rock audience
neither looked to
Broadway for
"street credibility,"
nor did they have
the inclination—
nor resources—
to visit Broadway.

As seen in a variety
of applications, this
page and opposite,
the stark street
vernacular of the
logo cuts through
the clutter of
signage, vehicles,
and structures
with an appealing
frankness.

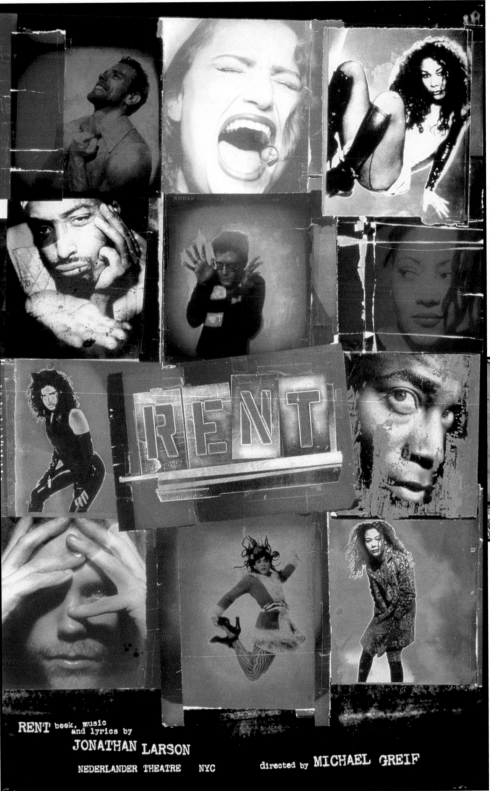

RENT book, music and lyrics by JONATHAN LARSON

NEDERLANDER THEATRE NYC directed by MICHAEL GREIF

Rent became the first Broadway show in more than ten years to be featured on the cover of a national color news weekly. *Time* magazine voted it the number one theater piece for the year. *The Wall Street Journal* estimated the total sales figures associated with *Rent* worldwide could go as high as one billion dollars.

Without a doubt the merits of the production have carried the day, but it was a clear, strategic marketing and design program that drove the initial response.

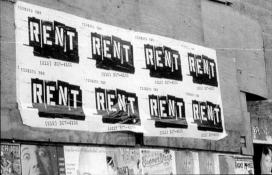

Putting a human face on the show, photographer/illustrator Guip used images of cast members, a break from Broadway tradition because individual actors may not be with the show throughout its run. When making her black-and-white prints, Guip used scratched glass, furthering the distressed look with a range of toning, sandpaper, and acrylic paints. Digitized individually, the photos can be replaced or reassembled depending on the flexible montage applications.

ESPN2

Rewriting the Rules
of Television Identity

The ESPN2 identity uses four versions of the logo, with the numeral 2 being the consistent factor. Above, the original "piano key" version.

CLIENT
ESPN
Stamford, Connecticut

CLIENT CONTACT
Noubar Stone, Creative Director

DESIGN FIRM
PMcD Design
New York, New York

ART DIRECTOR
Patrick McDonough

PRODUCER/DIRECTOR
Scott Danielson

DESIGNER
Dale Robbins

COMPOSER
Eve Nelson

DIGITAL FX EDITOR
Amy G. Davis

DIVERSIFICATION, WHETHER THROUGH endorsing additional areas of commerce or creating new brands, has long been a hallmark of economic success. Television is no exception, with its long history of spinoffs. Sports cable television network, ESPN saw an opportunity to draw in a younger demographic and set out to create ESPN2.

The network came about in two phases. The first phase saw the repackaging of existing programming with a new attitude, through look, commentary, and coverage. The second phase happened over time and featured the addition of coverage of underpublicized sporting events: rodeo, bullfighting, motorcycle racing, and others, and the so-called extreme sports of snowboarding, skateboarding, and street-luging.

PMcD Design, having recently completed the Barcelona Olympic package for NBC, was tapped for the creation of the new identity. In its written proposal, PMcD Design declared it would "rewrite the rules of traditional television sports design and presentation." Avoiding flying three-dimensional logos, PMcD Design created a plan that covered all phases of corporate image, design development, graphic production, design systems, film direction, and music.

A success on all fronts, the network and design studio continue to move forward together.

Sports brackets (sport-specific graphics that unite programming elements) use vivid, high-energy color palettes, an innovative use of film color correction, and consistent typography to reinforce distinct areas of programming.

Sound and music design become vital pulses as "live" performance samplings of rock and roll, jazz, R & B, rap, hip-hop, thrash, melodic, and punk rock create an aural component of the ESPN2 identity.

espn2 toyota grand prix
monterey, california

plained

BICYCLE STUNT
VERT-FINALS

15 competitors

90 seconds per run

avg. of 3 runs

100 point scale

Simple, legible typography provides sports scores and other data against a rich framework of everchanging backgrounds. Hand-painted line art, below, is used for title bars, as seen at left.

MINNESOTA PUBLIC RADIO

WERNER DESIGN WERKS, INC.

Building Consensus and Community

TRADITIONAL MARKETING MODELS —with such measurable, quantitative methods as demographics and number crunching—have long served Minnesota Public Radio, which has grown from a small radio station to a large network of stations serving a broad constituency.

In focusing considerable energy on addressing this growth and responding to immediate day-to-day needs and issues, promotional literature had taken on a variety of looks. Over time, the MPR identity became fuzzy. With funding cuts and limited promotional dollars, creating a strong brand identity and implementing the coordination of effective communication pieces became paramount to achieve fund-raising and promotional goals with fewer financial resources.

Nonprofit corporations are constantly under the watchful eye of donors, underwriters, and the press, all of whom often question expenditures. Certainly there are those who view design as window-dressing, not clear on its cumulative effects. Add to this MPR's egalitarian desire to build consensus within their corporate populace, and it's easy to see how the design process could falter.

Overcoming frustrations and learning to appreciate the viewpoints of its team members, Werner Design Werks and MPR have begun to build an identity that can stand the test of time and criticism.

Exciting but not flashy, the mark conveys a warm and approachable personality. The broadcasting of ideas and information is represented in a simple yet elegant manner: sound waves; the ripple of a stone tossed in a pond. Lowercase italic letterforms give the mark a conversational, unpretentious tone.

CLIENT
Minnesota Public Radio
Minneapolis, Minnesota

CLIENT CONTACT
Rob Dewey, Marketing Director

DESIGN FIRM
Werner Design Werks, Inc.
Minneapolis, Minnesota

ART DIRECTOR
Sharon Werner

DESIGNERS
Sharon Werner, Sarah Nelson

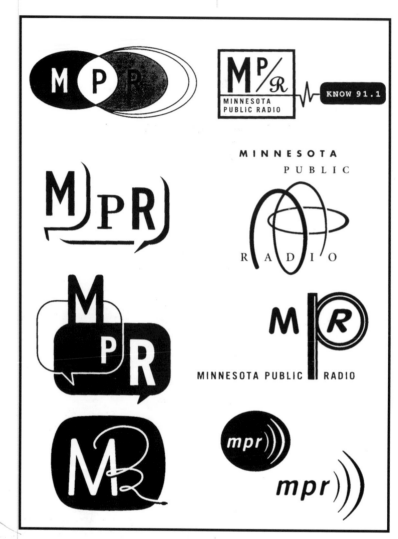

Criteria for the above explorations reflect MPR's status as a regional radio network of stations, a producer of national programming, broadcaster of classical music, news, a nonprofit organization, Internet publisher, and an integral part of the community.

Design directions pursued concerns about being perceived as non-intimidating, approachable, and innovative, while giving an accurate representation of rank and file members as educated, sophisticated adults who were community oriented and proud of their Minnesota heritage.

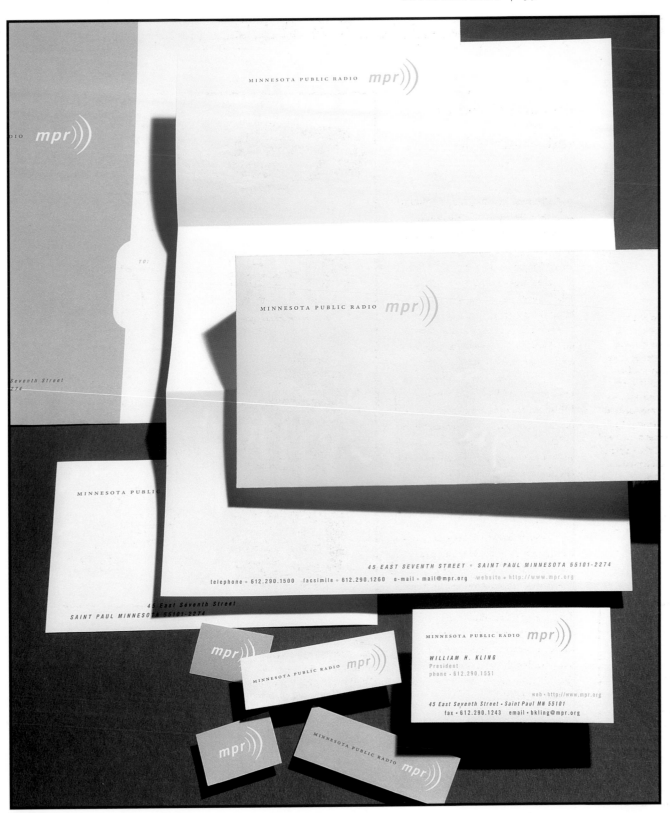

A redrawn Helvetica, with slightly rounded corners, complements Garamond No. 3, subtly blending the old and the new.

CLIENT
The Mirage
Las Vegas, Nevada

CLIENT CONTACT
Matt Heligman, Creative Director,
 Hal Riney & Partners
John Schadler, VP Corporate
 Communications, The Mirage

DESIGN FIRM
Studio Archetype
San Francisco, California

CREATIVE DIRECTOR
Clement Mok

DESIGNERS
Chuck Ruthier, Sandra Koenig

THE MIRAGE
STUDIO ARCHETYPE

From Ordinary to Extraordinary:
Something Out of Nothing

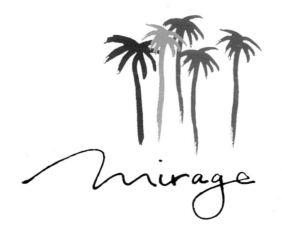

LAS VEGAS. THOSE TWO WORDS CONJURE UP A FLOOD OF images, but they can barely keep pace with the multifaceted reality of the fastest growing city in the United States. The city has been enveloped in aura since the beginning.

A dust mote on the 1930s map of Nevada, Las Vegas began to grow when Ben "Bugsy" Siegel and nefarious funding brought about the birth of the Flamingo, a hotel and casino, in the 1940s. The "Rat Pack"—Frank Sinatra, Sammy Davis Jr., Dean Martin, Peter Lawford, and Joey Bishop—immortalized the Sands in the 1960s. By the end of the decade the Sahara, the Stardust, and Caesar's Palace all had gained footholds on the fiercely competitive Strip. Elvis Presley, influenced more by perennial Las Vegas performer Wayne Newton than by the rockabilly cats or R&B wailers of his youth, gave us the 1970s version of the city: bursting at the seams in vainglorious excess. With "Viva Las Vegas" as its motto, Elvis impersonators, money, neon, dancing girls, prostitution, and quickie weddings, Las Vegas has become a city of unique character. Even novelist Stephen King used the city as the nadir of evil in his book *The Stand*. And of Newton, Merv Griffin once said, "Las Vegas without Wayne Newton is like Disneyland without Mickey Mouse."

Disneyland is exactly the reference point magnate Steve Wynn used when considering the Mirage, the first new hotel/casino on the Strip in fifteeen years. Entrepreneurial spirit has been one of the deciding factors in the fate of Las Vegas, and Wynn sought to make his latest project a destination in and of itself. If the Disney approach was entertainment and fantasy for children, the Mirage would bring that same level of imagination and excitement to adults. The intent was to give new meaning and attitude to the resorts of Las Vegas, as well as to attract a younger generation that may have been suspicious of many of the stereotypes listed above, and give visitors interested in Las Vegas a specific destination.

Preliminary planning and development was done with the Jerda Partnership, known for their involvement with the 1984 Olympics and the Horton Plaza development in San Diego. There a strip mall was converted into a festive destination for tourists and visitors, not unlike Boston's Fanueil Hall Marketplace or South Street Seaport in New York City.

To drive his strategy, Wynn turned to Hal Riney and Partners, the San Francisco advertising agency that had been handling his other accounts. For development of the corporate identity, the agency had several prominent designers from either coast take a crack at it. The idea was to bring in a designer or studio that had no

Literally one of the last squiggles on the page of potential marks, Mok's solution is warm and captivating.

The inset on the opposite page highlights the Mirage's landmark volcano. In the background, the perimeter of the outdoor stadium is wrapped in fabric.

industry-related biases, to bring a fresh look to the category. The mark and subsequent identity needed to exude personality and character. This first phase of logo development eventually went to Clement Mok Designs.

In business for less than two years, Mok had spent considerable time at Apple Computers as creative director for special corporate events and education. During that time, Mok was heavily involved with Apple's merchandising and catalog, which gave him a good grasp on the Mirage's potential needs.

According to Mok, "Steve is a showman at heart, with a Barnum and Bailey-like intuitive sense of what middle-America loves." With that sense, Wynn was planning to turn the ordinary into the extraordinary. Plans included an enormous volcano that erupts every fifteen minutes after dusk, tropical lagoons and grottoes complete with waterfalls and four-hundred palm trees, and a 20,000-gallon (76,000-liter) aquarium stocked with stingrays, a myriad of tropical fish, three kinds of sharks, and an artificial coral reef.

Creating an identity to amplify the tropical experience—fun and fanciful—while staying simple and sophisticated became a challenge, pushed "more by emotional response and creative possibilities than rational thinking," says Mok.

Several versions of the mark were worked out based on the premise of "I'll know it when I see it." But the design studio was behind the curve, hurrying to get a mark ready to meet the needs of a vast merchandising plan, as well as to prepare a standards guide

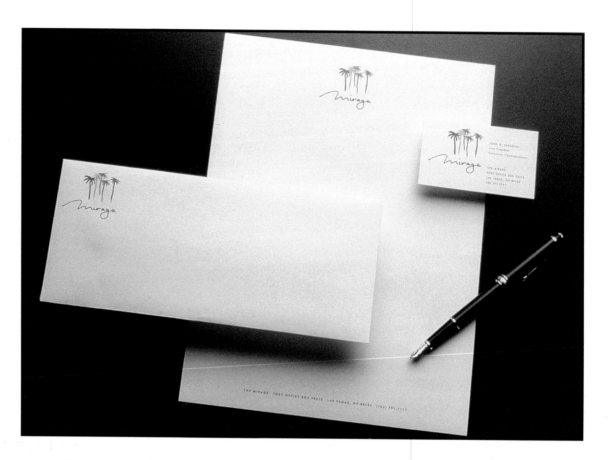

Secondary typefaces for the identity include Bodoni as the preferred font for signage, advertising and promotional literature. Futura is specified for headlines and other complementary purposes.

to assist the Mirage's management group in producing a variety of items.

The mark had to address the image of the resort and could look nothing like any other mark on the Strip. After it was approved, the guides were implemented. The studio drew up color and typographic specifications for merchandising and a core set of room amenities, then designed and implemented the casino chips and a variety of key merchandising elements, setting the tone and style.

The tone and style has worked so well, in fact, that the Mirage has spawned an amazing merchandising and licensing industry. With that, their legal department has had to react to international bootlegging and copyright infringement, as the Mirage logo has been found on unlicensed items around the world.

The Mirage, home of Siegfried and Roy's Royal White Tigers, has spawned a new era of spectacle in Las Vegas and appealed to a new audience since its opening in 1989. Treasure Island, a spin-off operation, was opened as a family-oriented venue. This benchmark approach dramatically affects the business community, which in turn shapes the city's development direction.

Census Bureau figures released in October of 1995 show the Las Vegas population jumped 26 percent between 1990 and 1994, making it the fastest-growing metropolitan area in the nation. The September 1995 issue of *Money* magazine ranked Las Vegas as number nine, up from forty-three last year, of the best places to live in the

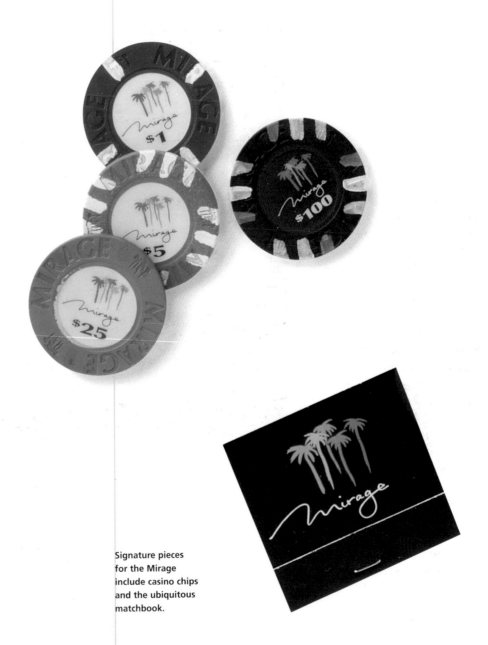

Signature pieces for the Mirage include casino chips and the ubiquitous matchbook.

United States. "Las Vegas is transforming itself from the U.S. gaming capital into a mecca for young ambitious families who may never set foot in a casino." With the Mirage having raised the stakes, they can only benefit from the unparalleled growth in the city.

The identity Bugsy Siegal first created for his version of Las Vegas is slowly but surely giving way to new visions and, in the end, a new identity.

(Since the inception of this project, Clement Mok Designs has grown from seven to seventy people and has taken on the name Studio Archetype, with offices in San Francisco and New York.)

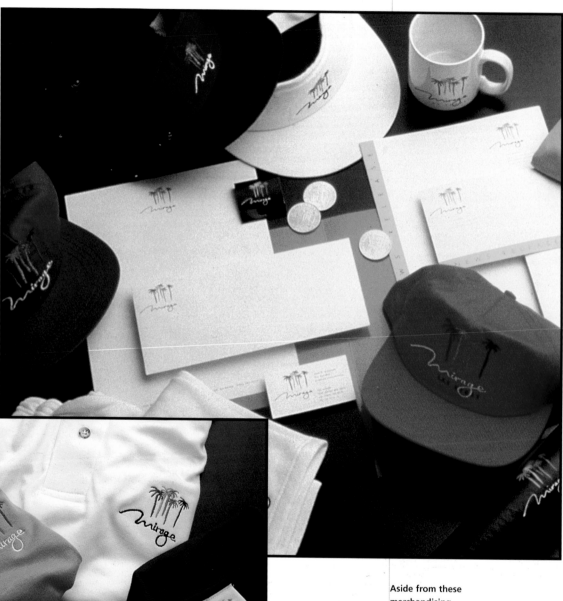

Aside from these merchandising items, an internal department works on house organs, carrying the identity through a range of communication materials.

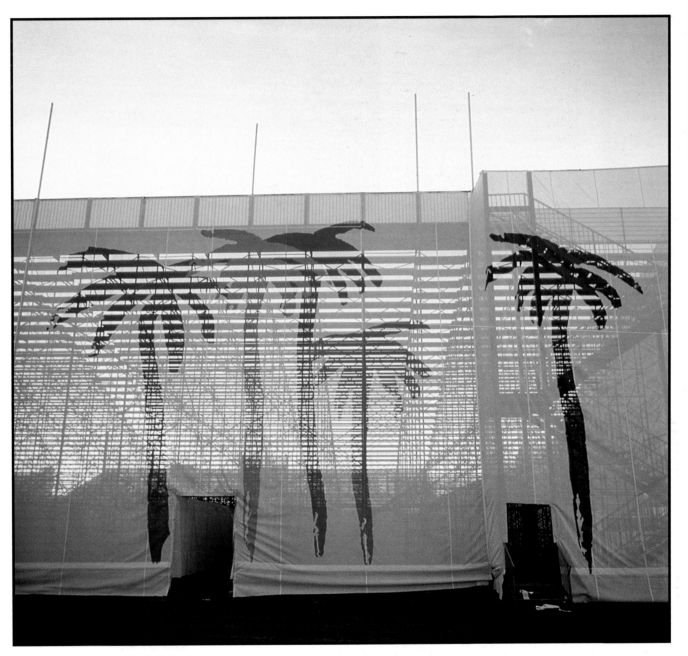

Morning light shines through the fabric-wrapped stadium seats, used for outdoor events such as the historic Holyfield-Tyson boxing match.

BREW MOON
PLUS DESIGN INC.

Hand-crafted German signs were an inspiration for the stencil letter-forms, which have been laser-cut on business cards and letterhead.

CLIENT
Brew Moon Enterprises Inc.
Boston, Massachusetts

CLIENT CONTACT
Elliot Feiner, President

DESIGN FIRM
plus design inc.
Boston, Massachusetts

ART DIRECTOR
Anita Meyer

DESIGNERS
Anita Meyer, Jan Baker, Dina Zaccagnini

LETTERING
Jan Baker

ARCHITECTS
Darlow Christ Architects
Cambridge, Massachusetts

Integrating Philosophy and Experience

IDENTITY HAS BEEN USED to drive many successful local, national, and international dining establishments. A key to that success has been the complete integration of components. The Brew Moon Restaurant & Microbrewery, a contemporary brew pub, did just that by making a team of the owner, architects, executive management, and plus design.

A design and marketing brief outlined demographics and defined customer groups by dining times. This led to dividing the conceptual areas of product, atmosphere, and brewing tradition into specific percentages for emphasis in the identity.

The team worked jointly to incorporate a visual communication system with the architecture and interior design. Brew Moon's palette blends romantic shades of blue and purple with accents of gold, amber, and copper, all representing moon and beer tones.

Through conceptual integration of the restaurant and microbrewery, the team created a unique contemporary dining and drinking experience. With the brewpub's success, several more restaurants are scheduled to open in the next few years. As Brew Moon establishes new restaurants the "process" and "philosophy" friezes (facing page) will remain the same, while the "site" frieze will reflect the restaurant's location.

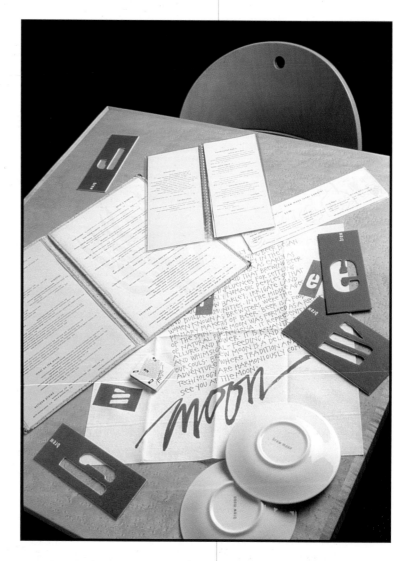

Menus are laser printed on preprinted shells using Roman and Bold Condensed New Gothic, then slipped into transparent menu sleeves bound with a plain steel wire-O binding.

Coasters are replicated stencils in the blue-purple palette.

Brew Moon's written philosophical statement is featured on each napkin and T-shirt.

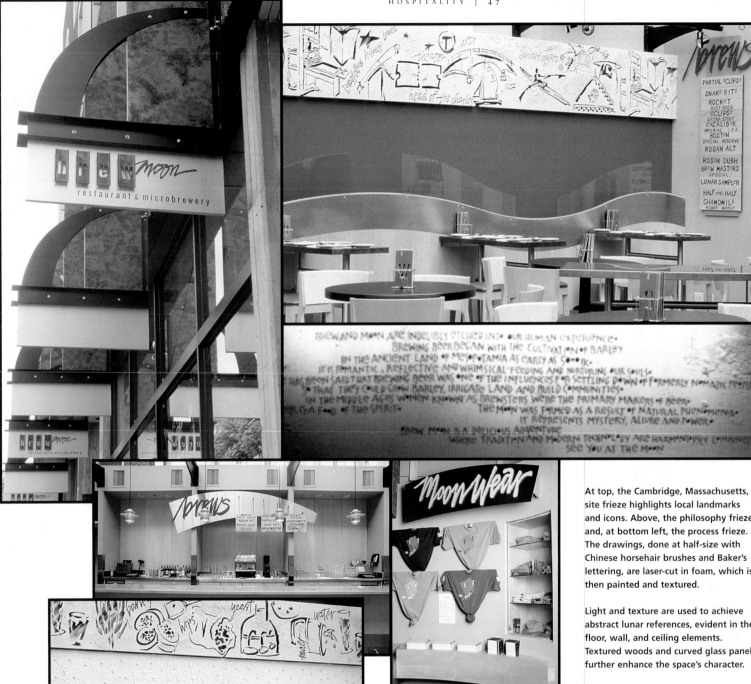

At top, the Cambridge, Massachusetts, site frieze highlights local landmarks and icons. Above, the philosophy frieze and, at bottom left, the process frieze. The drawings, done at half-size with Chinese horsehair brushes and Baker's lettering, are laser-cut in foam, which is then painted and textured.

Light and texture are used to achieve abstract lunar references, evident in the floor, wall, and ceiling elements. Textured woods and curved glass panels further enhance the space's character.

Identity applications include signage, napkins, coasters, menus, uniforms, T-shirts, gift certificates, ads, and invitations.

OAXACA GRILL
GRETEMAN GROUP

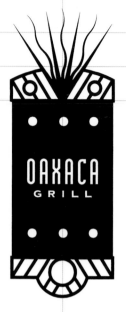

The restaurant's stylized mark reflects an ancient Spanish influence, yet offers a distinctly modern feel.

Industria, with Copperplate as a secondary font, form an elegant combination.

CLIENT
Oaxaca Grill
Wichita, Kansas

CLIENT CONTACT
Paul Spurlock, Proprietor

DESIGN FIRM
Greteman Group
Wichita, Kansas

ART DIRECTOR
Sonia Greteman

DESIGNERS
Sonia Greteman, Craig Tomson, Jo Quillen, Chris Parks

ILLUSTRATOR
Sonia Greteman

Evoking a Rich Cultural Legacy

WHEN OAXACA GRILL OPENED the region's only MesoAmerican restaurant, it needed an identity to position it as a fine-dining establishment—not your average chips-and-salsa joint.

The meticulously designed restaurant's hand-forged bar stools, Zapotec tapestries, and black hematite pottery create a comfortable yet elegant dining spot in Wichita's historic Old Town district.

Through careful research, Greteman Group built on the restaurant's articulate personification of the ancient city of Oaxaca, Mexico, long known for its quality arts and craftsmanship.

Everything from signage to packaging asserts the unique qualities of the restaurant and its attention to detail. Details like the hand-made menu binder, complete with glued rivets, when added to the debossed, washable menus, follow in the footsteps of those Oaxacan craftsmen and echo their origins from another era. The final identity system allows Oaxaca's Spanish and Mayan influences to flavor the imagery, but avoids blatant Spanish or Mexican representation. Here visual communication links with the restaurant's offerings, creating a compelling environment rich in tradition and texture.

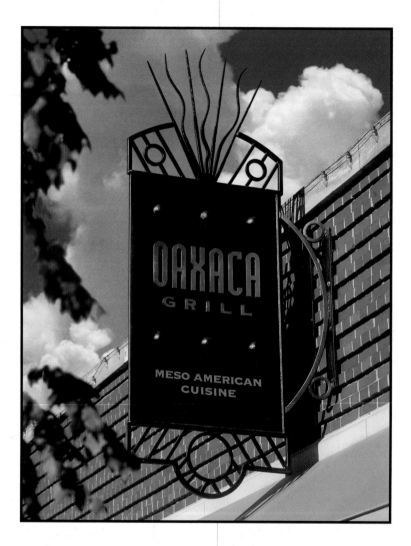

Hand-forged iron-and-steel signage with three-dimensional bronze channel letters, displays a distinctive craftsmanship that asserts the establishment's attention to detail and raises the expectation of a fine restaurant, and pays homage to the Spanish ironwork of Oaxaca, Mexico.

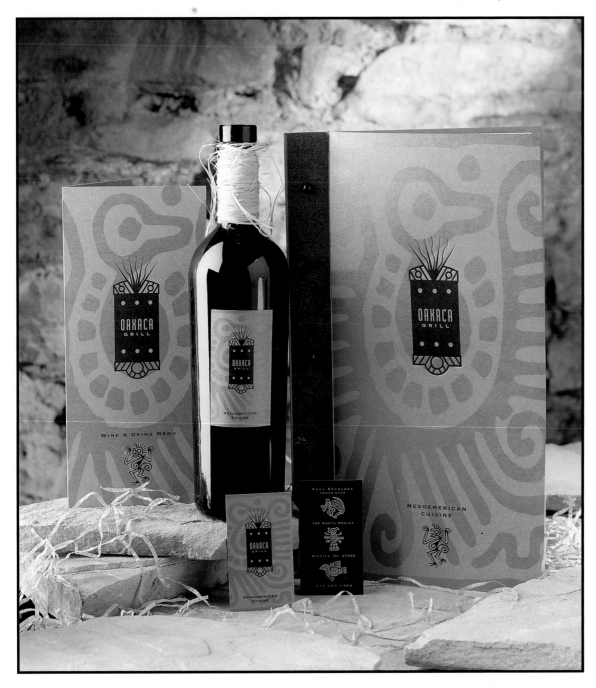

Zapotec Indian symbols, copper imprinting, embossing, and weathered metal bindings with rivets help create a feel of Old Mexico.

CENTURY SELECT

CENTURY

An archaic Seminole Indian symbol for fertility is given a new life when combined with typograpy of machine aesthetics, so prevelent in 1940s Art Deco.

CLIENT
Century Hotel, Restaurant, Bar

CLIENT CONTACT
David Colby, Wilhelm Moser
Proprietors

DESIGN FIRM
Select, in-house
New York, New York
Düsseldorf, Germany

ART DIRECTOR
Wilhelm Moser

DESIGNERS
Wilhelm Moser, Frank Müller

PHOTOGRAPHERS
Claus Wickrath, Ricardo Stanoss

Nomads Come in From the Cold

MIAMI BEACH, MULTILINGUAL visitors, and models make a heady combination writer David Colby and photographer/artist Wilhem Moser have grown accustomed to. Vagabonds since the 1960s, the pair have gone on to publish *Select*, an international photography showcase, with offices in Düsseldorf, Germany, and New York. Aimed at design and advertising professionals, each issue focuses on a different country or city. In this capacity they experienced the hospitality of hotels worldwide.

By the late 1980s the duo had become familiar with Miami, a warm haven for European photo crews. The publishers purchased Century at the beginning of a renaissance of Miami Beach's 1940s-50s Art Deco era. Their intent was to create the best of home and travel and to add a personal touch to all aspects of their enterprise.

Moser, visually literate, found an old book with native Seminole art, and redrew a lizard image for the Century logo. Full-page ads bearing only logo and logotype were run in *Select*, as was a one-time insert (designed in-house), which later doubled as a brochure.

Winning awards for interior design and façade preservation, word-of-mouth and travel guides have kept the hotel full. According to Colby, their memorable identity has had an "enormous impact" with guests and friends.

CENTURY

HOTEL · RESTAURANT · BAR · 140 OCEAN DRIVE · MIAMI BEACH · FLORIDA 33139 · PHONE 305-674.8855 · FAX 305-538.5733

Above, the eight-page, 9 1/2 inch x 13 inch (24 cm x 33 cm) brochure was printed on the same heavy, uncoated, off-white paper as *Select*'s editorial pages.

Inside, inviting and evocative photography captures the rich detail of the hotel and its environment. Laid out on a simple four-column grid, unobtrusive typography allows the photography to be front and center.

Wickrath's *Portraits of the Century* series, at right, features employees, guests, patrons, and friends, all part of the establishments extended "family."

The array of items the logo has been applied to reads like a vacation shopping list: beach towels suntan lotion notecards pencils menu covers dinner plates match boxes ice buckets stickers jewelry shower curtains key chains cigarette lighters bandannas temporary "tattoos" the ubiquitous T-shirt . . . and a wrought-iron table (in the form of the logo) that graces the hotel lobby. In short, anything that may come up on a whim.

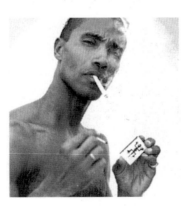

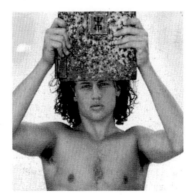

INSTITUTIONAL

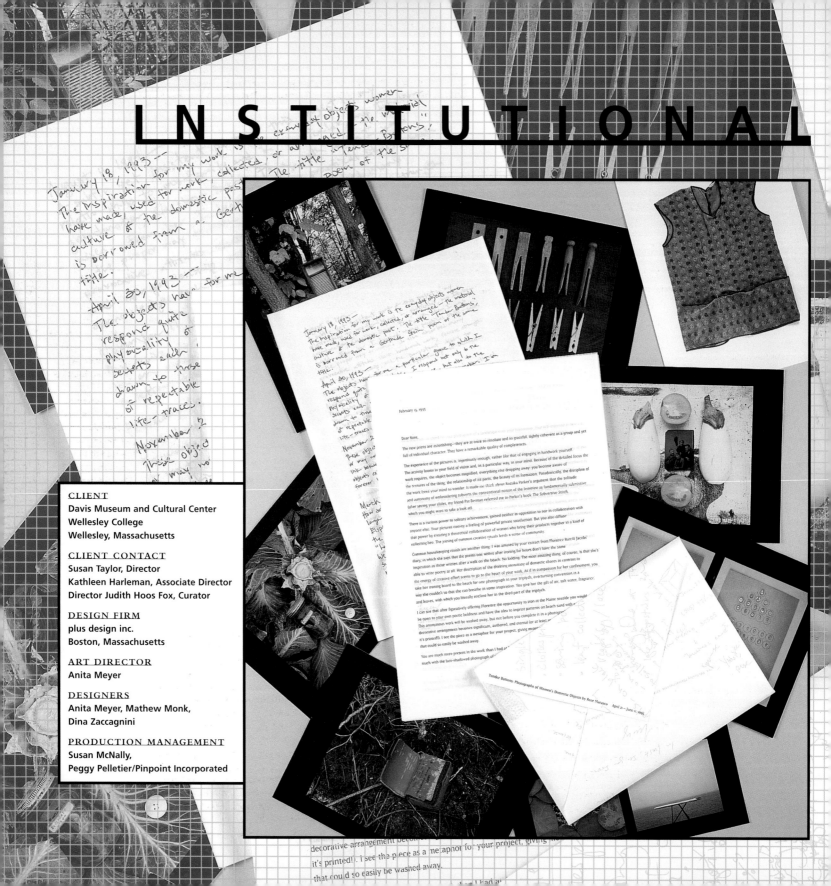

CLIENT
Davis Museum and Cultural Center
Wellesley College
Wellesley, Massachusetts

CLIENT CONTACT
Susan Taylor, Director
Kathleen Harleman, Associate Director
Director Judith Hoos Fox, Curator

DESIGN FIRM
plus design inc.
Boston, Massachusetts

ART DIRECTOR
Anita Meyer

DESIGNERS
Anita Meyer, Mathew Monk,
Dina Zaccagnini

PRODUCTION MANAGEMENT
Susan McNally,
Peggy Pelletier/Pinpoint Incorporated

DAVIS MUSEUM AND CULTURE CENTER
PLUS DESIGN INC.

Community-minded Goals Enhance an Architectural Statement

MORE AND MORE, INSTITUTIONS FACE THE SAME PRESSURES as corporations. They vie for scarce financial resources, in the form of membership and membership fees. They seek the support of community leaders; businesses and their endowments; and, when applicable, funding grants. With such a variety of "consumers," an organization's identity stands the chance of becoming generic in the attempt to be all things to all people. Like so many businesses run by those whose chief focus is inward on product, the notion of getting that product to market is forsaken, and the role of communication is not considered.

Wellesley College, a mid-sized liberal arts school, west of Boston, has had the privilege of seeing their museum grow with programming and an encyclopedic collection. The museum has moved all over the campus, outgrowing space and buildings. The most recent move demanded construction of a new building, which provided an opportunity to emphatically position the museum.

In the past the museum existed as a teaching facility, used by faculty and students in art classes. The present incarnation serves dual purposes: as a teaching facility for the Art Department and as a fine arts facility for the entire college community and the general public.

As one of the most public extensions of the college, the museum plays a major role. A long sought-after goal has been to maintain a balance between being an independent entity and an integral part of the college.

The museum's primary constituency is the students, faculty, and administration in the Art Department. Then come related academic departments and the rest of the campus. Other audience tiers include Wellesley alumnae; museum patrons (Friends of Art); other colleges and universities; the town of Wellesley and its schools, contiguous towns and schools; special interest groups (artists, architects, and photographers); and museum associations, historians, and museum professionals worldwide.

A medium-sized, nonprofit organization, the museum (neé, the Wellesley College Museum) has been working with plus design since 1985. The design studio is well versed in museum work, having completed a comprehensive identity for the Art Gallery of Ontario and additional work for The Getty Center for the History of Arts and Humanities in Santa Monica and the Barbara Krakow Gallery in Boston. Prior work for the Wellesley College Museum included a variety of publications and the rollout of the museum's identity celebrating its centennial. The centennial campaign helped launch fund raising for the new building.

The identity system combines subtle shapes, proportions, textures, and materials from the building to achieve a layered, expandable system of parts relating to a whole. Blind embossed rules, angled cuts, and perforations parallel the museum's unique design by Spanish architect Rafael Moneo.

Opposite page, documenting the exhibition *Tender Buttons: Photographs of Women's Domestic Objects*, the team of photographer, curator, and designer created a publication that, like the work presented, defied convention and expectation. The atmosphere of this personal and intimate work suggested the inclusion of a draft letter from curator to artist, pertinent diary notes in the artist's handwriting and a group of postcards that both illustrate the letter and serve as domestic objects themselves. In this spirit, the envelope was made into a collage with elements of the artist's and curator's own letters.

ANNE-MARIE LOGAN

FLEMISH DRAWINGS IN THE AGE OF RUBENS

SELECTED WORKS FROM AMERICAN COLLECTIONS

DAVIS MUSEUM AND CULTURAL CENTER
Wellesley College

The new museum's exhibit of Flemish drawings from the age of Rubens, organized by the world's leading scholar of Flemish drawings, was the first to examine seventeenth-century Flemish draftsmanship in more than fifty years. The exhibition catalogue provides a reinterpretation of late nineteenth- and early twentieth-century drawing books and folios.

The oversize format, following the size and proportions of its antecedents, allows the drawings to be reproduced at a large scale, some at actual size. The book is bound to open flat, making it easier to view the images. The paper is a specially calendared, uncoated off-white stock that suggests the patterns on which the drawings were originally executed. The red glorified spine employs a color traditional to the book arts; the uncovered bookbinder's board recalls folio covers; the debossed corners refer to the leather-bound corners of historical books. The typography is based on historical conventions that have been rethought, as the analyses of the drawings offer new interpretations. While alluding to the history of folios in general, this publication embodies a rethinking of tradition.

Common size and typography are unifying factors in this postcard series of exhibit announcements. Paper, ink color, and images differentiate each piece.

With a strong working relationship in place, plus design generated a new design and marketing brief, which established a foundation and program, that got team members—design studio, curators, educators, and administration—on board. The brief's goal: to make decision-making objective, not subjective. Says Meyer "We can design toward whatever those criteria need to be." This vital element provided a point of departure.

Though the museum consists of the facilities, the collection, the programming, and the people, the team realized the key point was that the museum was more than simply the building that houses it. Because the building and the collection are physical elements, it would be easy to let them represent the museum, but the identity shouldn't neglect the museum's intangible elements—its spirit, history, programming, etcetera.

The brief outlined the museum's philosophical goals: to push boundaries in thoughtful, probing ways; to pose probing questions; to take risks that are substantive, meaningful, and appropriate—not gratuitous; to experiment in an organized fashion; to provide simultaneous, multilayered experiences; to show and encourage differing points of view; to present and explore other cultures; to provide interdisciplinary approaches to research and interpretation; and to apply new methodologies to traditional disciplines. These well-thought-out goals became underlying criteria for all that was to be developed.

The team discussed the use of a

The Give-and-Take Process

"IT TOOK ME A WHILE TO convince them that I'm not married to any of this stuff. I'm not sensitive about what we have to change. If it's not working, it's not working. Let's make it work." That's Anita Meyer's position. She feels fortunate to work with a team that appreciates and trusts her studio's contribution and is comfortable giving them criticism. They negotiate, as the studio feels like—and is treated like— part of a worthy institution.

Meyer may fight hard for what she believes in—she does fill the role of visual communications specialist—but she isn't inflexible. If something doesn't function, costs too much, doesn't serve the purpose, or doesn't reach the right audience, she's quick to shift gears. "This," says Meyer, "is about working toward the criteria for a specific communication." This refreshing *esprit de corps* is furthered by studio members being invited to openings and special dinners, and receiving acknowledgment for work done.

"They are wonderful clients who do not put limitations on our studio, nor do we put limitations on them. As the institution changes, as programming changes, the materials will evolve. Nothing is precious."

Two things are certain: One, things will change; two, they will be done as a team. Successful relationships of all kinds require trust, faith, and give-and-take.

Published for art historians, students, and museum visitors, this compact handbook provides a selected inventory documenting the breadth and significance of the Davis Museum's encyclopedic collection. In its history section, the handbook honors those who formed the collection, built the museum buildings, and introduced the Wellesley Method of teaching art history with a studio component. Objects from the collection are presented in chronological sequence, with carefully paired images on facing pages. The book cover is a substantial, brick-colored paper stock with a die-cut window, alluding to the material and design of the new building. The window reveals the image of one of the most important objects in the collection printed on the reverse side of the cover fold.

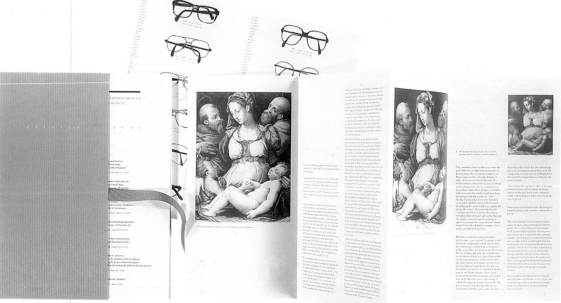

Centennial year brochures and holder for the Jewett Arts Center, predecessor of the Davis Museum and Cultural Arts Center.

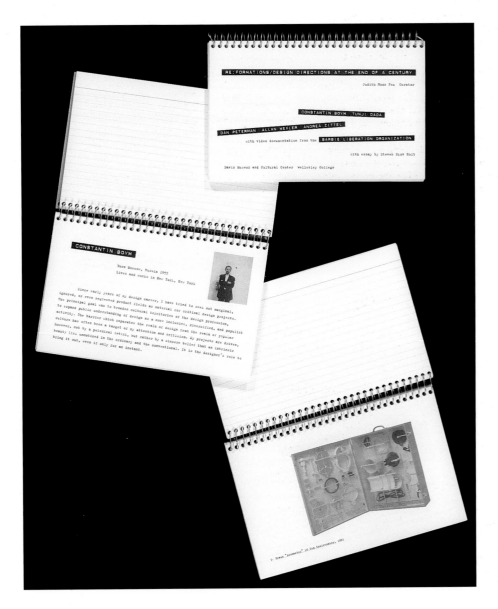

This catalog was for an exhibition based on found or manufactured objects artists have drawn into new configurations without altering or concealing their original function.

By printing on the unlined side of an index card, the viewer is encouraged to reuse the catalogue for notes or sketches. Printing on the cards proved difficult, as the paper fibers were an uncontrollable problem. Collated and bound by hand, blank cards were inserted into the catalogue to represent a standard fifty card spiral bound book.

symbol based on the architecture. Several architectural features are prominent within the museum, which while contemporary in appearance, has been influenced by the region's old mill buildings.

Clerestories—windows placed high in walls, used for light or ventilation—are a prominent feature, as the architect was keen on capturing views of the campus through these windows, paying respect to the site and other campus buildings. A grand staircase slices through the building. Diagonal markings throughout the building suggest the plan that interior spaces can expand or contract depending on programming or exhibits. Gallery spaces are based on double squares.

Deciding not to do the obvious—creating a symbol, based on the clerestory—the studio developed the combination of a wordmark with a visual system approach. Conceptual elements from the architecture nevertheless served as inspiration, with double squares and diagonal components used throughout identity items.

Meyer states, there is "no mystery" to the studio's design process. They start with typography and what intrinsic values certain letterforms communicate. Materials are judged by whether they add meaning. Legibility remains one of the most important items. That said, concept drives the project and, ultimately, budget creates the parameters within which they must work. Constant constructive feedback from their team keeps the studio on their toes.

But nothing is carved in stone and change is inevitable. An early series of

invitational postcards, economically produced on a translucent stock, had to change as additional programming information had to be added, calling for a complete redesign.

The initial identity lays a firm foundation by introducing the new museum. While the museum still wants and needs to be an essential part of the campus, as stated in their original goals, it also intends to grow beyond its community. Understanding an audience's needs and responding to them are critical to any organization. To gauge these needs, the museum has begun to use focus groups, a method of soliciting opinions, adopted from the corporate world.

Still in the process of examining its audience, the team has become more selective about criteria for reaching certain kinds of audiences and addressing their needs. Though the audience doesn't make the decisions, its point of view is acknowledged. "Some very slight adjustments can make someone very happy," says Meyer, "which in turn would make them visit the museum more frequently. That is the goal."

The museum is now moving through a second phase of visual communication: reevaluating materials—some will be altered, indicative of the strength in programming—and moving away from the strong reflection of the architecture. Though the museum has a strong publications program, it too is open to reevaluation, driven by questions about intent, programming,

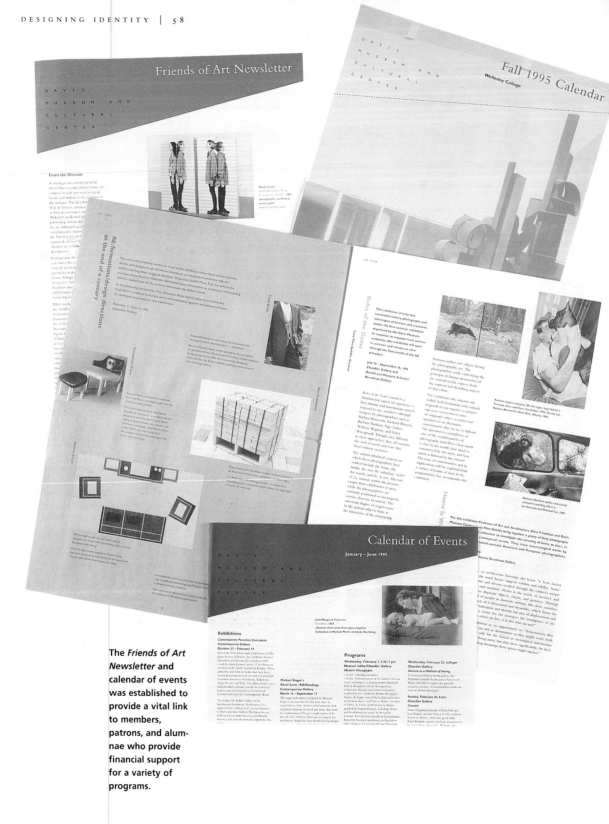

The *Friends of Art Newsletter* and calendar of events was established to provide a vital link to members, patrons, and alumnae who provide financial support for a variety of programs.

recognition, distribution, expenditures, and allocations. As Meyer says, "We are now making decisions specifically based on reaching particular audiences."

With the purpose of the museum and cultural center constantly being sharpened, the bottomline continues to be raising awareness and profile by focusing on the audience.

General information brochure for the museum and Friends of Art membership brochure.

CHILDREN'S MEMORIAL MEDICAL CENTER
ESSEX TWO INCORPORATED

New Look Reinforces
a Theme of Caring

The prior logotype consisted of lettering that in its attempt to be child-like proved to be childish instead.

Here, a condensed Garamond has been redrawn, with caps 10 percent smaller. Both ascenders and descenders have been shortened.

CLIENT
Children's Memorial Medical Center
Chicago, Illinois

CLIENT CONTACT
Holly Hallen, Director of Public
 Relations and Public Affairs

DESIGN FIRM
Essex Two Incorporated
Chicago, Illinois

PROJECT DIRECTORS
Joseph Essex, Nancy Denney Essex

DESIGNERS
Joseph Essex, Nancy Denney Essex

PHOTOGRAPHY
Mary Beth Johnson

A CHILDREN'S HOSPITAL IS different from other hospitals for three reasons. First, when children are ill, their treatments must take into account the fact that their bodies are continuously growing. Second, unlike adults, children are usually not the ones responsible for their illness. And third, since many small children can't tell the doctor where it hurts, the parents are an integral part of the communications and are essential to the child's treatment. These concerns were paramount to a board of directors that is very protective of the success of the hospital, which was founded in the 1920s.

After a review of three other firms, as well as the hospital's internal department, Essex Two was awarded the task of creating both a new name and logo that reflected the unique position of Children's Memorial Medical Center, one of the world's leading children's hospitals.

Essex Two interviewed more than sixty parents, patients doctors, nurses, fund raisers, and administrators and found two important issues kept surfacing. First, every child is unique; second, Children's Memorial exists only for children, accepting all child patients, and often handling the most severe and endangered children.

Drawing on the individual child as inspiration, Children's Memorial has continued to build upon its position of leadership in the health care community.

Patient Care
Research
Education
Advocacy

Children's
Children's Memorial
Hospital

The reaching hand logo is based on the first gift children often give their parents—a handprint in clay.

Photography for ads, print collateral, and TV spots requires the viewer to make eye contact with the children in the photos, as in this report cover.

A small brochure with a trim size of 4 inches x 6 inches (10 cm x 15 cm) was used to introduce the new identity.

Every child is unique.

This statement was made again and again in many different ways during the more than thirty interviews with members of the Children's Memorial family.

And because at Children's, the focus is on each individual child and family, our new trademark needed to reflect that spirit. Our new symbol showing a child's hand, reaching and hopeful, will convey to all who see it our commitment to children and our mission on their behalf.

Children's
Children's Memorial
Medical Center

Essex Two created an electronic identity manual for the in-house design team's use. Other parts of the initial project rollout included signage, vehicle applications, and on-air titling for new TV spots.

NORTH AMERICAN NATURE PHOTOGRAPHY ASSOCIATION
MELANIE METZ DESIGN

Developing an Idea;

Hatching a Logo

N A N P A

A graceful render-
ing of parent and
offspring waterfowl
works well against
the rectilinear forms
of a strip of film.
Herman Zapf's
Optima, with its
equally graceful
letterforms, is used
for the logotype.

**THE NORTH AMERCAN NATURE
Photography Association (NANPA)
is one of eleven nonprofit**
associations managed by the Resource
Center for Associations (RC), which
serves NANPA by managing member-
ship, running meetings, and handling
finances.

Developed in 1994 to represent a
new, national photography association,
NANPA's mission is to unify profes-
sional and amateur photographers,
promote awareness of professional
ethics and, most importantly, to nurture
young photographers.

As director of NANPA and a part-
ner in RC, Jerry Bowman saw no need
to incur the expense of a logo, given the
organization's limited funds. However,
as a visually literate group, the board
members (many involved with both the
Sierra Club and the American Society
of Media Photographers) were adamant
about having a mark of their own.
Members' dues support all levels of
programming, and the logo would act as
a banner they could all rally 'round.

President Jack Lakes brought on
board Melanie Metz, with whom he
had worked previously, to develop the
new mark. After several iterations and
serious input from the board, the mark
was ready to be implemented. With
two thousand members nationwide, this
relatively young organization has built a
recognizable image within its community
and is rapidly growing, almost outpacing
the services provided by RC.

Metz's initial
sketches, seen
above and right,
were heartily
debated among the
board members, all
well-known nature
photographers.
On one side were
the "purists"
who felt the birds
must have near
photo-realistic accu-
racy. The other
group of photogra-
phers could see the
mark in the context
of a symbol, with
more stylized birds,
that communicated
photography,
nature, and the
nurturing of young
photographers.
Refinements based
on photographs of
birds produced the
final result.

CLIENT
North American Nature
 Photography Association
Wheat Ridge, Colorado

CLIENT CONTACT
Jerry Bowman, Executive Director

DESIGN FIRM
Melanie Metz Design
Fort Collins, Colorado

ART DIRECTOR
Melanie Metz

DESIGNER
Melanie Metz

With the budgetary constraints of many start-up groups, financial parameters were set. The mark had to print successfully in one color—usually black—and be easily reproducible. With the association's focus on the environment, all applications had to be printed on recycled paper.

ROCK & ROLL HALL OF FAME + MUSEUM
NESNADNY + SCHWARTZ

The final mark—of hundreds prepared—refers to the Hall of Fame's signature architecture and a guitar neck.

Twenty-four color schemes for the logo, based on a palette of six official colors, are outlined in the electronic logo files.

CLIENT
Rock & Roll Hall of Fame + Museum
Cleveland, Ohio

CLIENT CONTACTS
Edward Bailey, Marketing Director
James Henke, Chief Curator

DESIGN FIRM
Nesnadny + Schwartz
Cleveland | New York | Toronto

CREATIVE DIRECTORS
Mark Schwartz, Joyce Nesnadny

DESIGNERS
Tim Lachina, Brian Lavy,
Michelle Moehler

PHOTOGRAPHY
Tony Festa (collection),
various (people and events)

"One for the Money, Two for the Show . . . "

AS ANYONE WHO HAS PLAYED in a band knows, it's not easy to reach a consensus. Now imagine a sixty-person Board of Directors—half local civic leaders, half big enchiladas of the New York music trade—reaching agreement over an identity for a museum hoping to put rock 'n' roll on an international pedestal.

With Cleveland officials wanting to push the landmark architecture as destination and the music industry folks understandably wanting to play the musical angle, things seemed as potentially messy as the sound of a room full of lead guitarists. Four New York studios and one Cleveland studio were each paid $2,500 and asked to create the logo.

The competition narrowed down to two, as Nesnadny + Schwartz (N+S) readied their third spiral-bound book of concepts. With the board leaning toward a solution from the remaining New York firm, N+S went back to the drawing board one last time. Going beyond their contractual obligation, N+S presented the logo in a variety of potential applications.

Awarded the project, the N+S team turned to creating an identity they knew from the beginning would be more than just a logo. With little artifice, the vast collections of photographs and memorabilia have been deftly applied and juxtaposed. Far from creating a cacophony, the components present rhythmically dynamic visuals, with a rock-steady beat.

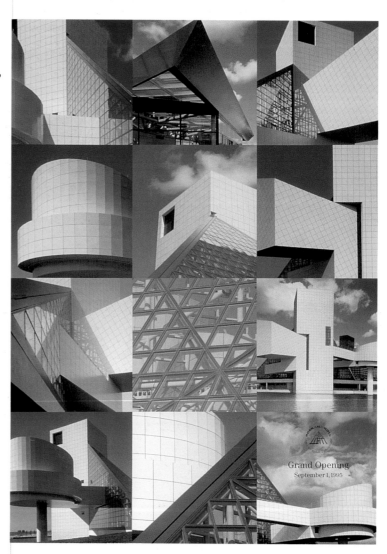

Grand Opening
September 1, 1995

Above, the Grand Opening poster displays a gamut of architectural details from the I.M. Pei-designed museum. At right, the Grand Opening concert program.

As with all the pieces, typography responds to specific needs and isn't rigid like a standard corporate identity plan.

Top, letterhead, envelopes, and business cards are printed two-color on front. The halftones on back feature the guitars of Elmore James, Carl Perkins, Jimi Hendrix, Pete Townshend, and other pieces such as Elvis's porcelain "Nipper" dog.

Below, components for the membership direct mail campaign printed in process color, two fluorescent inks and varnish make the relatively small piece jump visually. It generated revenues approaching two million dollars and fifty-thousand new members.

Top, the newsletter details exhibit, film, performance, and lecture schedules.

Below, the official calendar features collages by N+S and Custom Graphics combining concert posters, artist photos, instruments, and outfits.

Other components designed by N+S included a fund-raising brochure and exclusive merchandise.

BOWDOIN COLLEGE
COREY McPHERSON NASH

Looking Forward;
Acknowledging the Past

THE
NEW CENTURY
CAMPAIGN
FOR
BOWDOIN

The college uses images of the sun, a polar bear, and a pine tree as part of their iconography. A new dynamic sun symbolizing growth was created for the campaign. Adobe Garamond was chosen for its Old Style figures.

CLIENT
Bowdoin College
Brunswick, Maine

CLIENT CONTACTS
Alison Dodson, VP/Communications
Hilary Bassett, Writer

DESIGN FIRM
Corey McPherson Nash
Watertown, Massachusetts

PROJECT DIRECTOR
Michael McPherson

PRINCIPAL DESIGNER
Kristin Reid

DESIGNERS
Jeff Gobin, Chris Wise, Doug Rugh

PHOTOGRAPHY
Jim Harrison

ONE OF A FEW ELITE, SMALL liberal arts colleges in New England, Bowdoin College in Brunswick, Maine, embarked on an endowment-building $113-million capital campaign. These campaigns generally seek donations from those with the closest ties to an institution—alumni. Soliciting this audience requires a clear message of appeal.

The design team conducted several days of interviews with Bowdoin administrators, alumni, and campaign leaders, defining criteria to govern the design process. The main question was how to strike a balance between the Maine location, which alumni were fond of, and its stature as a national and even international educational resource. Not wanting to be perceived as local, the college officials found themselves at a turning point, ready to position the school in the upper echelon of education.

Cognizant of existing materials and armed with valuable insight, the Watertown, Massachusetts, team of Corey McPherson Nash recommended a color palette of green, gray, and beige to connote local history and tradition, while emphasizing educational prominence with a sophisticated layout of photographs and text.

Multiple revisions done in alliance with the college president made for a better series of pieces that succinctly addressed the core message. Though still under way, the campaign is on target and, like the college, moving forward.

Paper plays an important role when called upon to express certain attributes, in this case a low-key sophistication and sense of long-standing tradition. For Bowdoin's capital campaign, the design team specified the highest quality uncoated papers for all aspects of the project.

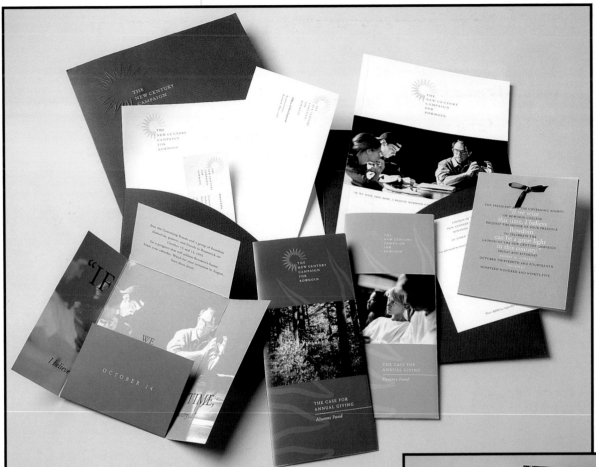

The five-spot-color print run avoids connotations of excess—an anathema when fundraising—with black and gray duotones.

The photographs, much discussed in advance while surveying the campus, were nevertheless not art directed. With available light and the occasional strobe, the candid shots reinforce the serious purpose of the materials and reflect a perception of quality and tradition.

Above, the complete literature package includes presentation folder, case statement brochure, Annual Giving brochures, newsletter, and campaign kickoff invitations.

Several photographs and interviews with alumni, students, and friends of the college, slated for the case statement brochure, at right, were nixed for the sake of brevity. This valuable information was later used in the newsletter.

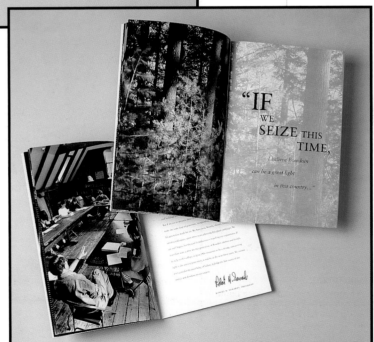

PACKAGING

CLIENT
Tazo Teas
Portland, Oregon

CLIENT CONTACT
Steve Smith, President

DESIGN FIRM
Sandstrom Design
Portland, Oregon

CREATIVE DIRECTOR
Steve Sandstrom

DESIGNERS
Steve Sandstrom, Janée Warren,
Amy Devletian

COPYWRITER
Steve Sandoz

TAZO
SANDSTROM DESIGN

Infusing Teas with Quality, History, and Spirit

THE ESSENTIALS OF LIFE ARE FEW: FOOD AND SHELTER. Short of settling for the most base versions of either, humans have for millennia been inbuing both with qualities they find satisfying. At some time in our past, our ancestors first added to water—whether to reduce acidity or alkalinity, for medicinal purposes, spiritual purposes, or for plain old taste—some type of leaf or herb. They've been doing it ever since.

Tea rituals have developed throughout Asia and England. Coffee is enjoyed in endless variations of strength from Abu Dhabi to Zimbabwe. And one of the most recognized brands in the world belongs to a carbonated beverage whose original flavors were derived from the coca leaf and cola nut, one hundred- some-odd years ago. Clearly, we take our consumption seriously.

In 1993, Steve Smith had a successful tea business, Stash Tea, that he had built over twenty-five years from a small mail-order service to a substantial enterprise, particularly in the food service area. By 1994, after fighting tooth and nail to hold on to it, he was leveraged out by an overseas firm, which had acquired enough stock.

Licking his wounds and seeing other companies moving into the high-end tea market, Smith resolved to stay in the business he knew so well. He also was aware that ready-to-drink, noncarbonated beverages were a hot category, seen as alternatives to soda, as demonstrated by Snapple's success.

Restaurant and other food service clients had often asked the Stash team to develop an alternative to iced tea, possibly some kind of fruit-based infusion. Likewise, natural groceries had expressed interest in special products. And the tea men were interested too.

Steve Lee, the gifted "tea master" at Stash whose responsibility it was to concoct flavors and drinks made from tea, joined in the venture. Lee and Smith had learned a great deal from their years at Stash. Food service, the area they were most comfortable with, would be the easiest market to penetrate with a hot tea program. While constantly inventing new products for the food service industry, they didn't have that same experience in retail arenas. Yet the pair did see an available market for better tasting, all-natural, ready-to-drink bottled tea and fruit juice products. That would call for a retail slant, which they recognized as a tougher category.

Needing guidance in retail marketing, Smith and Lee turned to their friend, Steve Sandoz, creative director at Weiden and Kennedy, one of the country's leading advertising agencies. They respected his marketing skills, as well his upbeat approach.

Exocet was slightly modified for the logo, adding a cross-stroke to the Z.

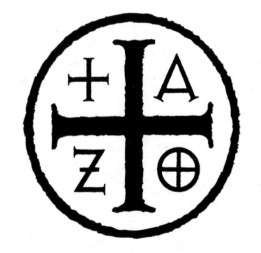

The circular Tazo logo resembles an alchemist's mark, with a letterform in each quadrant.

Opposite page, Sandstrom experimented with creating embossed, textured, or patterned filter paper for the bags. Costs for the "watermarked" papers dictated otherwise.

What it soon came down to was the element of packaging, which they believed would be the force driving sales. With that, Sandoz referred the tea team to Steve Sandstrom, with whom he'd collaborated on several projects over the years.

The four Steves got together and brainstormed. There was no company name, no specific product, just an idea: make interesting, high-end tea products. Two themes kept recurring that suggested a persona for the new company, which Smith had been planning for quite some time. The first, the notion of a meeting between the thirteenth-century traveler and chronicler, Marco Polo, and the medieval magician Merlin. One part unquenchable thirst for discovery, one part mysticism and magic. What would they drink at such a encounter? Something common, yet exotic, no doubt.

It was left to Sandoz to name the entity and give voice to the style of writing. The name Tazo, which may exist in some language, sprang from the recesses of Sandoz's imagination. Sandstrom's task was to give the newly named entity a visual existence. Both worked toward an inscrutable yet venerable identity, but with a wink and a nod.

Smith was immediately taken by it. He felt it met his criteria—ancient, new, inventive, interesting, and different. It could be Persian, Asian, or European. In his mind it did all of those things. Lee was a bit hesitant.

The first thing Sandstrom did to bring Lee around was to make "toys."

Background artwork, a rubbing from the "Tazo stone," is actually a series of alphabet tables from Hebrew, Phoenician, Tibetan, Hindi, Arabic, and other languages.

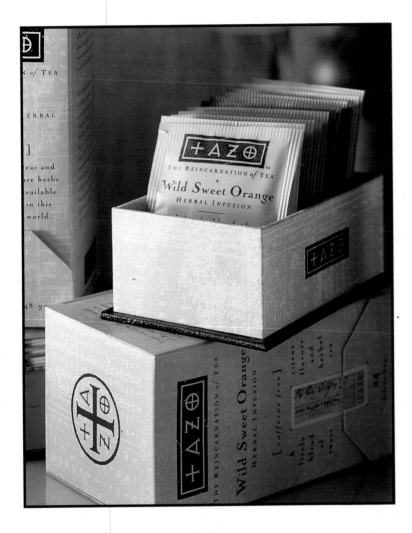

Packaging uses a standard look and feel for the entire line, relying on product-specific text and highlight colors, as seen on the tea bags, above.

He had an artist carve a Chinese-like soapstone chop of the logo, which Lee could use as his personal seal for correspondence. Lee received rubber stamps with his customized version of the circular logo enclosed by the words "Steve Lee, Tea Master." He also soon got on board.

The original plan was to start the ready-to-drink product first, but manufacturing and sourcing problems slowed things down. The hot tea program then became a priority. Mixes, formulas, bottling, preservatives, sediment, and natural product color became issues that, though overcome in time, were new factors for the group to contend with. So while Sandstrom worked on the identity, the packaging for the hot tea line was also under way.

Regarding risk, both packaging and product had their share. "Copy should intrigue them. We took a risk making it copy-heavy and gambled on the fact that people would read it. That [fact] is proven by the fifty letters we get a day commenting on our products," confirms Smith. And after packaging had been sent off to be manufactured, with ingredients listed, only then did the actual blending of the ingredients begin. Not the usual process. "Can I make tea that is as good as this packaging? That's the challenge," thought Smith.

Sandstrom shed a little light on the state of the market when Tazo made its move, "The Republic of Tea may have been the first to go after the high-end of the U.S. tea market and was certainly the first to use aggressive

Compromise:

the "Father of Results"

IF NECESSITY IS THE "MOTHER OF invention," then surely compromise is the "father of results." Timing and costs became an enemy to Tazo.

Sandstrom did an audit of existing packaging, before coming up with solutions. "Tea master Lee, a very creative guy, would have loved to have had everything in metal tins, have everything unique and fun," states Sandstrom, "but from a cost standpoint there is only so far one can go." Though the outlay of funds looks well spent, nothing is as originally planned. What exists are "compromises to materials, systems, and manufacturing," according to Sandstrom, "to time and money."

Even something as simple as the bag which holds the actual tea bag became an issue. The team had hoped not to use foil bags. While Stash had become know for exploiting the use of foil, Tazo's intent was to be more natural. But with a paper wrapper alone, aroma and, in turn, flavor are subject to dispersal, creating a short shelf life. A pragmatic solution was called for.

Tazo's first tea bag wrappers were clear cellophane with printing. Since then a variety of plastic-lined papers have been used. Similarly, all components have been affected.

Not evident to the consumer however, the team, though shooting for the moon, has had to stay a little bit closer to the earth.

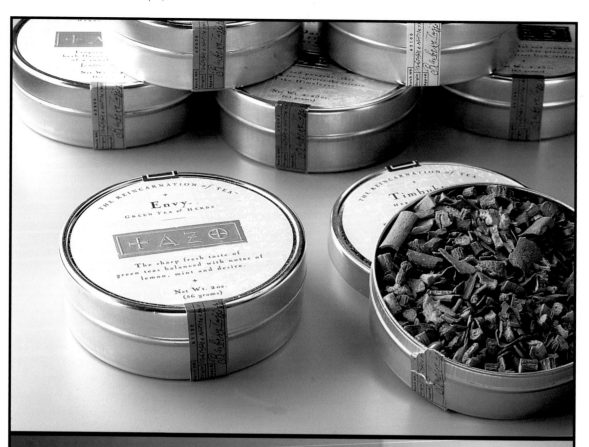

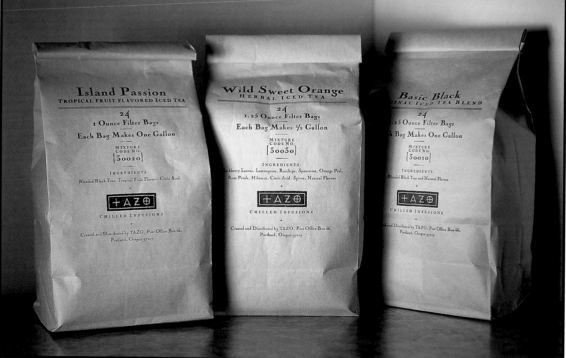

packaging in the tea world for any number of years. Much to their credit, they opened up room in this category, encouraging people to consider tea again, in a fresh perspective."

Tazo was never intended to be inexpensive. With the right herbs and leaves, tea can cost fifty dollars or more per ounce. The intent was to create a premium tea that was high in value. Smith's perspective is to load half again more product than normal into a filter, increasing tea flavor. When one tastes a cup of Tazo, "it's gonna go 'BOOM!'," according to Sandstrom. His studio's task was to create the visual equivalent of that "BOOM."

Customers love the product, enjoy the packaging, and have let Tazo know this in no uncertain terms.

Tazo has been incredibly successful in a short period of time. Within eighteen months Tazo reached the same point Stash took ten years to achieve. Even hot tea sales, which traditionally slump during summer months, have increased their volume during that period. Several factors have contributed to this success, but they all come down to experience and expertise in tea, marketing, and design, and aiming for the highest levels of quality.

Tazo sold well without trial, on packaging alone, something the owners never witnessed while at Stash. They found from experience what packaging could do to ease the sale. "Branding is critical," professes Smith. "Packaging is the first thing people see. The corporate identity compels people to pick up the package. We've not spent a penny on advertising and don't think we'll have to because of the enormous draw."

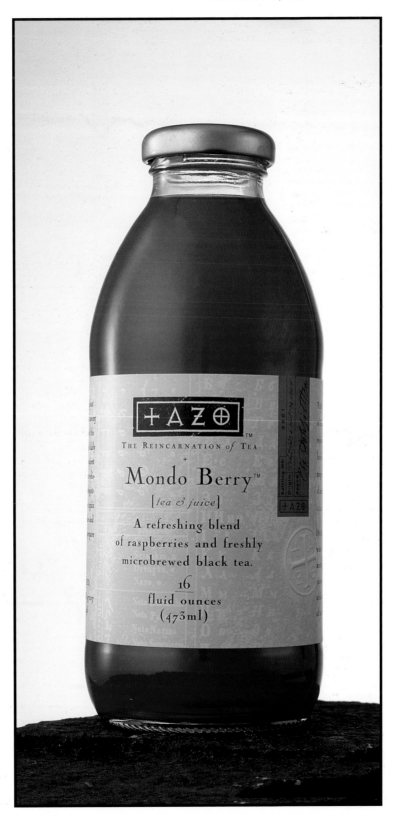

Nicolas Cochin has been used in several sizes and weights, but has been redrawn to achieve an overall consistency in weight, as seen in the bottle label typography, at left. "This stuff is really hard to set," states Sandstrom. "It's not fun when a Tazo project comes in and there is a lot of type to set. What looks like it should take one-half to one hour, usually takes two to three hours. When the client tries to do it [in-house for trade promotional literature], they can't figure out why their version doesn't look right."

Opposite page, top, the original idea for the tin was to have an embossed logo on the lid, seen through the label window. The "seals" are actually part of the lid label. Tazo also wished to have the labels all hand stamped, hand signed, and hand numbered. Practicality dictated otherwise.

Bottom, ready-to-make pouches for food service tea brewing have the Tazo look applied to the front.

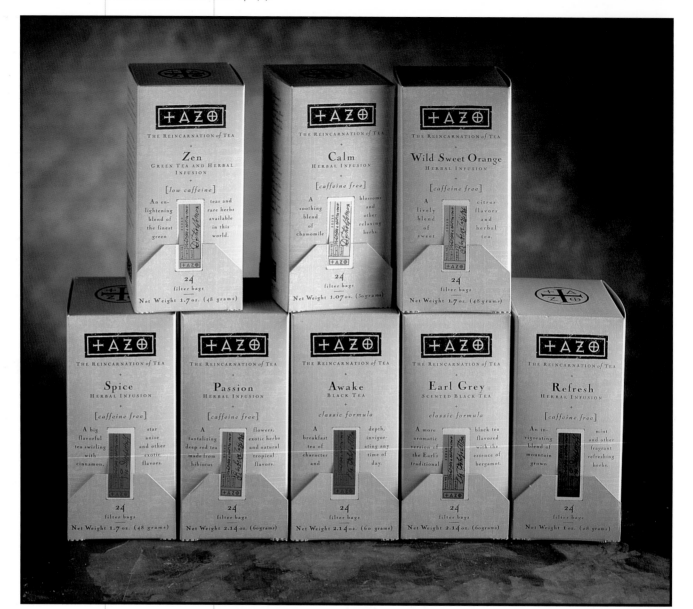

Sandstrom actually wanted the packaging to be more elaborate, with more handwriting and a more personal look. But it came down to designing eight packages in a few weeks to ready the product launch.

"I thought we'd get some devil worship comments because of the [mystic, gothic] look, and there has been a little of that, but nowhere near what I expected."

Tazo intended to print the hot tea box on uncoated stock, but standard stocks and sizes had be to used.

A new die was required for the tab at the bottom, a detail that could be accommodated.

The loading of bags into boxes at the manufacturer's end restricted the idea of changing how the box opens.

The only hint of color, in an otherwise black-and-beige scheme, is found in the seals and bags.

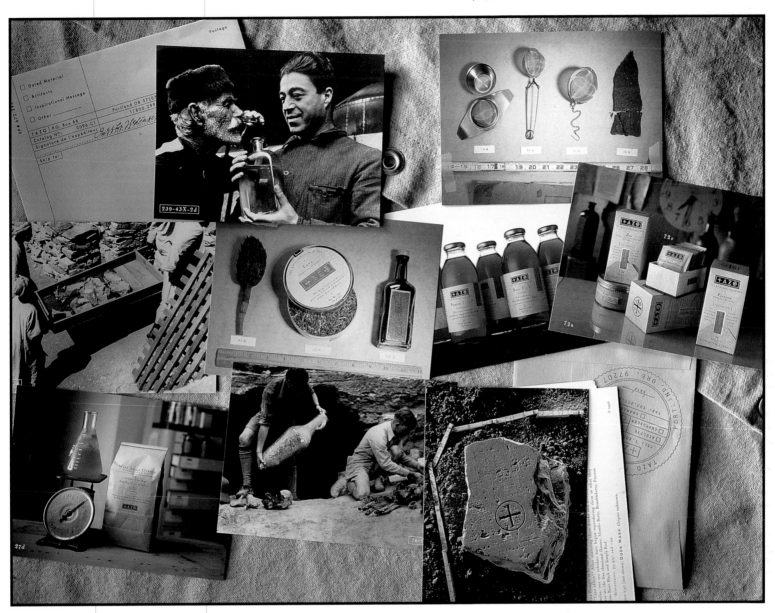

Though the post-card catalog doesn't fall into same look as the packaging, copy and attitude have the same subtle wit, using snippets of fake history and anthropology.

Sandstrom does a nonsense hand-writing style which is used on the "batch" seals designating "origin" and "approval." Listed among the tea ingredients are ". . . the mumbled chantings of a certified tea shaman."

KAMA SUTRA
MARGO CHASE DESIGN

A Pleasure for the Eye and Imagination

Earlier identities became dated quickly, looking too much like the time period when designed. Chase pointedly drew inspiration from classic Indo-Persian art for the logo. The cartouche refers to the lotus blossom, symbol of compassion, art, fertility, knowledge, and spirituality; lettering takes on the attributes of Sanskrit letter forms.

CLIENT
Kama Sutra Company
Westlake Village, California

CLIENT CONTACT
Joe Bolstad, President

DESIGN FIRM
Margo Chase Design
Los Angeles, California

ART DIRECTOR
Margo Chase

DESIGNERS
Wendy Ferris Emery, Margo Chase, Anne Burdick

ILLUSTRATOR
Jacquelyn Tough

COPYWRITER
Nina Dillon

THE 1960s: A DECADE OF FREE love, flower power, protest, and American youth challenging "the establishment." "Make love, not war!" became the inspiration for a pair of budding entrepreneurs. The company, Kama Sutra, which manufactures intimate body products, chose their name from the fourth-century Indian text on lovemaking, *The Kama Sutra of Vatsyayana.*

The original 1960s packaging, with black-and-white nude photos, proved a bit too risqué for some distributors and retail outlets. An effort to move their identity upscale resulted in rather sterile black and red packaging. Kama Sutra's president, a former art student, recognized the value the proper aesthetic would add—if they could interest high-end sales representatives in carrying his lines would open new distribution avenues in department stores, specialty gift shops, and boutiques, a twenty-year struggle would be ended.

Margo Chase, known for her sinuous and sensuous lettering and art, took the approach of creating a brand and look that was as steeped in history as the company name. Richly detailed and textural packaging alludes to the attributes of the original Hindu manuscript.

A beautiful array of packaging, product sheets, a website, and a direct mail catalog have provided a solid platform for relaunching Kama Sutra, stimulating both sales and the senses.

In keeping with their philosophy of stimulating all the senses, Kama Sutra's packaging lures and pleases the eye. The Hindu concept of sexuality as basically divine has resulted in many centuries of magnificent religious art. Exotic graphics, directly inspired by India's original illustrated *Kama Sutra*, have been richly hued and accented in gold, creating an alluring image.

Black, gold, and an earthy olive green are the central palette around which other lush colors provide a soft balance. Silk used in making the sari, a traditional Indian garment, became the basis for the canister art. Labels use four-color process and metallic inks and a matte aqueous coating.

Each piece has been designed with attention to the slightest detail. Stock cylinders, boxes, and reusable metal canisters hold handsome glass flacons, sleek plastic jars, and frosted plastic bottles, all custom tinted.

Illustrator Tough, painting in gouache, worked from several sources, studying carpets, textiles, and pictorial art for the wrap-around canister art.

Stock chipboard boxes are reincarnated with soft, luxurious colors. A delicate leaf-like, custom metal scoop provides the finishing touch for the aromatic bath salts, bottom right.

LIVE OAK BREWING COMPANY
KAMPA DESIGN

Hopping from
Avocation to Vocation

Live oaks are abundant in the Austin area and have a significant role in the city's history. Copperplate and Stymie Condensed Bold are the primary fonts; Poplar is a supporting font.

NOT LONG AFTER THEY introduced their home fermentations, Chip McElroy and Brian Peters were being encouraged by friends and fellow brewers to take the next step: brewing beer on a larger scale. Each had solid jobs and could have been content brewing for themselves, but McElroy had just finished a European tour of breweries, where he was able to commune with the beer gods, soak up excellent suds, and groove on major beer mojo. Austin had caught micro-brewery and brewpub fever and the budding brewers followed their hearts.

Referred to Kampa Design by a mutual friend, the pair first contacted the designer with a business plan but not much more, let alone money. But the duo knew a logo could help create interest among investors, in the beginning stages of fund raising, by letting potential backers know the venture was being taken seriously. The investment package they were offering seemed to be adequate compensation, and after doing his own extensive product testing, Kampa agreed to trade design services for a share in the company.

"The logo gave potential investors something visually tangible to complement our ideas," affirms McElroy. "It allowed them to easily picture product in the marketplace . . . investors realized we were not just a couple of half-baked home brewers."

CLIENT
Live Oak Brewing Company
Austin, Texas

CLIENT CONTACT
Chip McElroy, Brian Peters
Proprietors

DESIGN FIRM
Kampa Design
Austin, Texas

ART DIRECTOR
David Kampa

DESIGNER
David Kampa

ILLUSTRATOR
David Kampa

Early discussions involved likes and dislikes of various breweries' logos and labels, the tradition of old-style brewing techniques, and the meanings of symbols and icons associated with beer throughout history.

Old brewery monograms served as inspiration for the initial *LO* monogram, above, fusing the character of old-style German letterforms and the kitsch look of rendered "wood type."

Kampa tapped into resource materials provided by his clients for design exploration.

During the initial investment phase, McElroy felt an actual image of a live oak in the logo was missing and asked for a redesign to incorporate a tree.

After a couple of half-hearted attempts and unsuccessful tree renderings, above, Kampa finally captured the expansive tree in iconic form, top left.

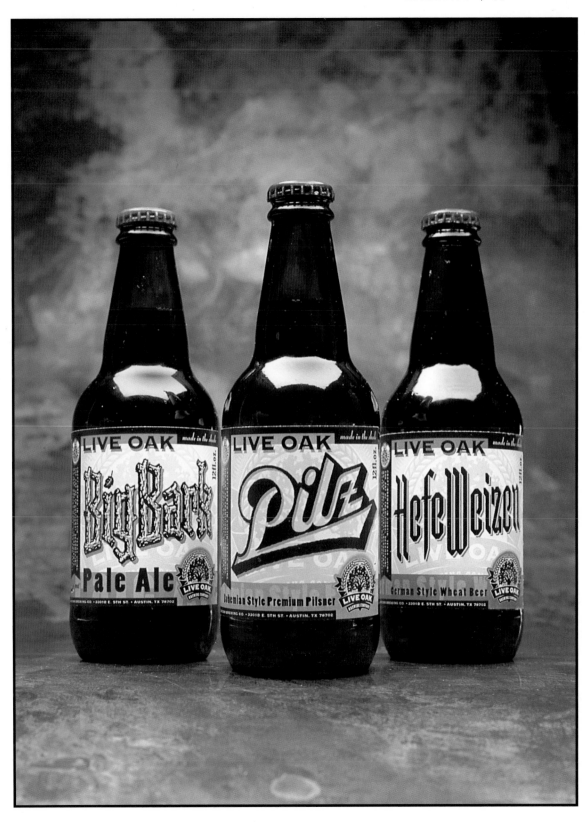

Three beers, each with its own identity, benefit from the overall brand approach of Live Oak Brewery.

A singular look to the labels serves as backdrop for unique product lettering. Beer name and label color are the only design elements that change.

The handcrafted lettering for the Bohemian-style pilsner refers to Art Nouveau motifs; the German-style brew likewise has appropriate lettering, where the pale ale approach is more whimsical.

The simple amber-and-black, two-color logo can be produced easily in any of the processes necessary for company merchandising, as seen in the T-shirt below, the beer tap at right, and beverage coasters, opposite page.

Color laser-printed business cards served the partners well during the brewery's preliminary stages. The final version employs two-color letterpress.

TERRANOVA
CRONAN DESIGN

Back to Basics:
The Three Rs

A modified version
of Gill Sans is used
for the logotype in
a variety of ways:
stacked, horizontal,
or as seen on the
distinctive cap
above, in a circle.

CLIENT
TerraNova
Berkeley, California

CLIENT CONTACT
Kathy Saunders, Executive Director

DESIGN FIRM
Cronan Design
San Francisco, California

ART DIRECTOR
Michael Cronan

DESIGNERS
Michael Cronan, Lisa Van Zandt,
Margie Goodman Drechsel

RETHINKING, REPOSITIONING, and redesigning have time and again been a simple formula for success. Since 1970, TerraNova has produced a line of high quality fragrances and scented lotions, shower gels, soaps, and environmental fragrances, formulated and packaged ethically, mindful of environmental responsibility.

Cronan Design's first suggestion was to reevaluate the effectiveness of producing 250-plus SKUs (shop keeping units). By keeping the top twenty products and then systematically growing the lines, TerraNova has been able to reintroduce itself at a higher level. The design challenge was to update, refresh, and refine the line of Perfume Essences as encompassing an entire scent palette, with a new twist on traditional fragrance families.

Each individual icon has its own personality, reflecting the spirit of the individual scent and referring to the fragrance family through a common design style. This provides easy visual cues to consumer and retailer with clear segmentation between the groups for easy identification and effective merchandising. Icon families were designed to reflect the five perfume essence categories and the modern nature of the scents. The harmonies of the fragrances' natural colors were an important consideration in choosing scents and creating families.

The revamped line has moved from small boutiques to Bergdorfs and Henri Bendel.

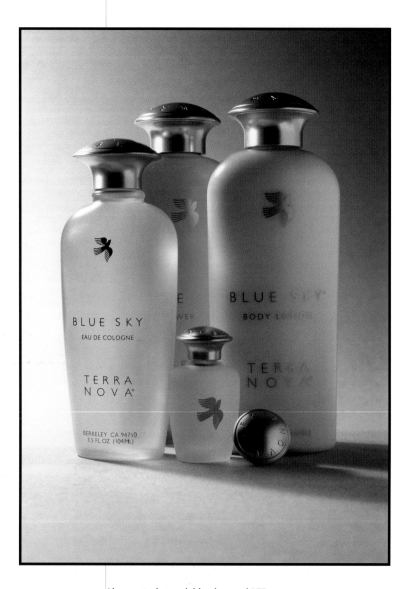

Above, stock recyclable glass and PET plastic bottles were selected, allowing several product–appropriate sizes without restrictive mold costs and high minimums. Instead of using PVC, the PET plastic is shatterproof, more recyclable, and glass–like in appearance when frosted. Silkscreening was done with lead–free, precious metal gold ink to coordinate with TerraNova's custom cap. The cap unifies and helps brand the product.

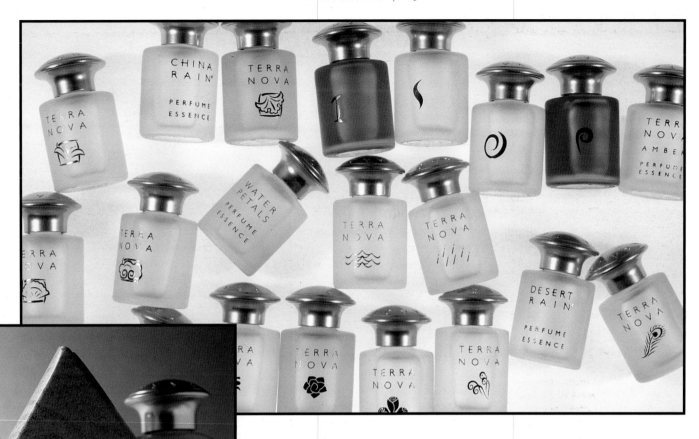

Blue Sky became the first new line to be introduced, once TerraNova had been repositioned. At left, Blue Sky's box incorporates the pyramid and papyrus design elements found throughout TerraNova's collections. They're constructed of low–cost 100 percent recycled materials (80 percent postconsumer waste, 20 percent preconsumer waste) and printed with soy inks. A printed insert offers a clear identity to each product and allows the boxes to become product and collection specific. At the same time, the inserts yield increased flexibility as product–specific information, such as FDA regulations, can be placed on inserts rather than boxes. The decision to use customized inserts allows TerraNova to minimize on–hand inventory of costly and bulky boxes.

For the TerraNova line, above, Cronan chose a simple, modern, cylindrical stock bottle to unify the product line. Having one bottle size for all the essences allowed the company to purchase the bottles and caps in quantities competitive with larger companies, reducing the unit cost. Cost savings allowed for a custom cap mold, which is used on all products.

Taking advantage of the round shape, the bottle allows bolder graphics and double exposure, increasing shelf presence. The recyclable bottles were customized with satiny frosting and scent–specific silkscreened graphics. A low VOC frosting process was chosen specifically for environmental reasons. Silkscreening was done with a lead-free ink.

TROPICAL SOURCE
HALEY JOHNSON DESIGN COMPANY

Listening and Addressing
a Need Pay Off

Tropical Source.

The hand-drawn
logotype adds a
freshness that could
not be achieved
with a tight
rendering.

With a plethora of
"hand–drawn" type
readily available,
personality is often
lost as ready-made
scripts often
become generic and
lose personality.
Here, a one-of-a-
kind face works
as intended.

**LONG ASSOCIATED WITH HIS
family–owned company, Caswell
& Massey, Joshua Taylor has**
made it a point to keep his ear to the
ground within his industry. When
retailers at industry trade shows spoke
of the dearth of dairy–free chocolate
products, he was quick to respond.

Taylor, aware that consumer
market packaging makes the sale, turned
to designer Haley Johnson, who had
worked on his successful Cloud Nine
line while with C.S. Anderson Design
Co. His prime directive was to make it
bright and colorful. The target audience
was health-conscious shoppers at natu-
ral and gourmet food markets. The suc-
cess of the colorful, animated packaging
has transcended many market niches.

Johnson worked out a fee struc-
ture based on sales, with a ceiling, met
within a year, making it cost–effective
for Tropical Source and a further induce-
ment for Johnson to do great work.

While much design goes on to
win awards, clients are even more
pleased when they win industry–specific
kudos. In 1994 the Tropical Source
packaging went on to win First Place
at the New York Fancy Food and
Confection Show. Tropical Source has
been the most successful product intro-
duction in Taylor's entire career. With
this line claiming more than 50 percent
of the natural chocolate niche and more
than 50 percent of Cloud Nine's gross
sales, it's safe to say it's been a satisfying
venture for all involved, and the financial
benefits have been more than palatable.

CLIENT
Cloud Nine, Inc.
Hoboken, New Jersey

CLIENT CONTACT
Joshua Taylor, President

DESIGN FIRM
Haley Johnson Design Company
Minneapolis, Minnesota

DESIGNER
Haley Johnson

ILLUSTRATOR
Haley Johnson

LETTERING
Haley Johnson

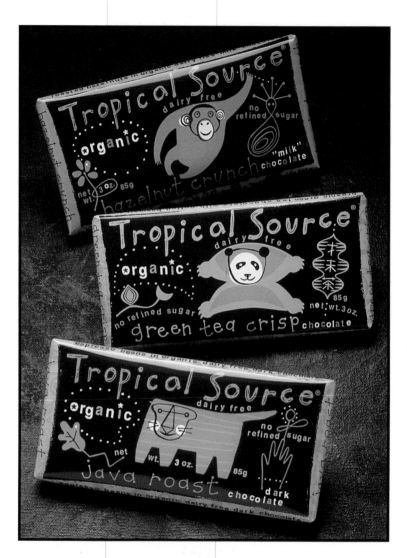

To keep production
costs to a minimum,
as well as create an
interwoven brand
palette, the three-
color wrappers use
black as a common
color. Of the other
two solid colors,
one finds its place
on two of the prod-
ucts. The white of
the paper acts as
highlight.

In the background
at right, Johnson's
lion sketch for the
*Lions & Tigers &
Bears* line of dairy-
free truffles, and the
final tiger chocolate,
foreground.

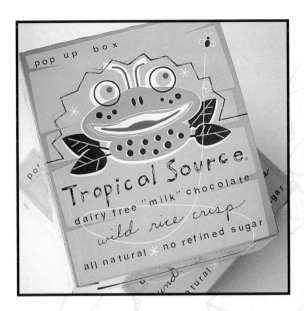

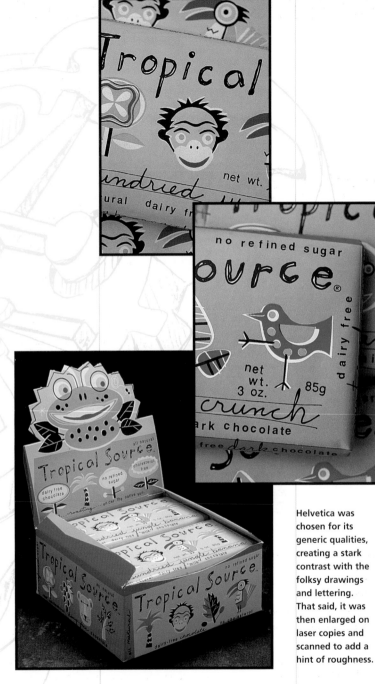

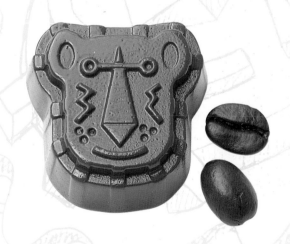

Helvetica was chosen for its generic qualities, creating a stark contrast with the folksy drawings and lettering. That said, it was then enlarged on laser copies and scanned to add a hint of roughness.

Unlike many manufacturers' product displays, the Tropical Source point-of-purchase display, as seen above and top left, is actually utilized by merchants. It functions as both shipping package and attention-grabbing showcase.

PRODUCT

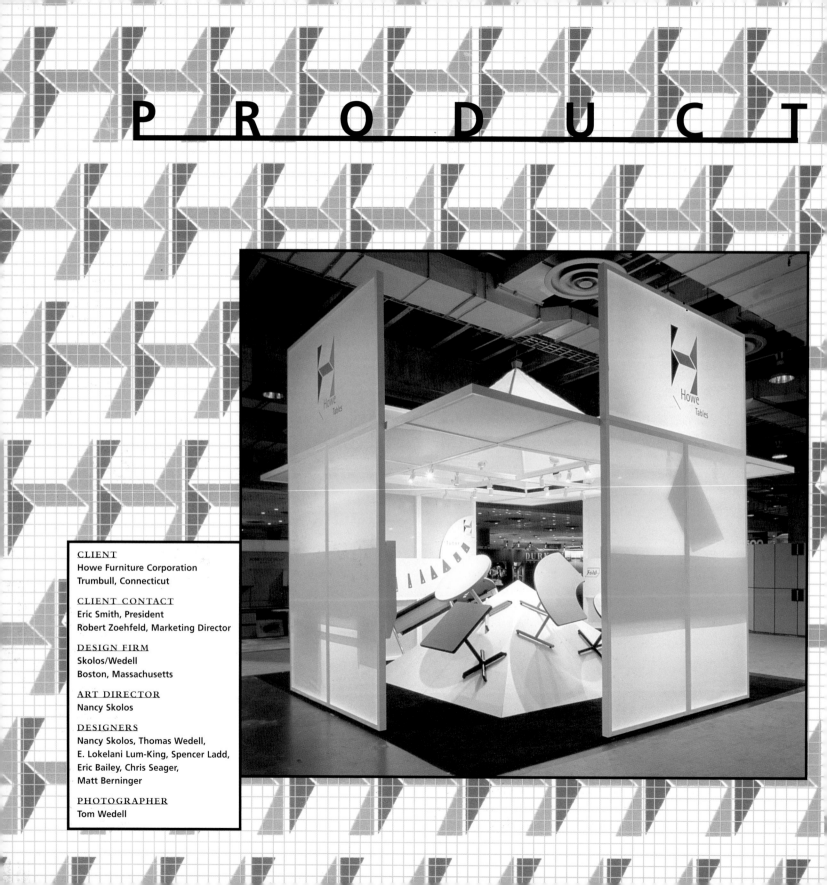

CLIENT
Howe Furniture Corporation
Trumbull, Connecticut

CLIENT CONTACT
Eric Smith, President
Robert Zoehfeld, Marketing Director

DESIGN FIRM
Skolos/Wedell
Boston, Massachusetts

ART DIRECTOR
Nancy Skolos

DESIGNERS
Nancy Skolos, Thomas Wedell,
E. Lokelani Lum-King, Spencer Ladd,
Eric Bailey, Chris Seager,
Matt Berninger

PHOTOGRAPHER
Tom Wedell

HOWE FURNITURE CORPORATION
SKOLOS/WEDELL

Skolos/Wedell Shows Howe
Furniture has New Legs

SIMPLY PUT, THERE ARE TWO KINDS OF PRODUCTS: new and old. In terms of commerce, each takes on different sales strategies. The new may rely on intrinsic novelty for initial sales. The old, with no kind of marketing push, rely on residual growth potential (RGP), which amounts to decreasing lead-time, eliminating persistent quality problems, and adding minor line extensions to prolong and extend the life of the product. With the new, design and marketing must create a new identity, a product persona. With the old, repositioning and presenting anew and integrating it with the new product's identity can contribute to a healthy and steady growth. Because what is old to one market may be new to those who do not know you.

In 1927 Howe Furniture supplied New York City's Waldorf Astoria with three thousand collapsible tables. Since then, Howe has become a leader in supplying banquet and convention furniture to the hospitality trade, as well as to a variety of educational and institutional facilities. In time, Howe developed a second business division, serving the contract furniture market, whose audience consists of interior designers and architects. Products in this line are aimed at training, seminar, and management configurations.

With a product life span of thirty to forty years, the company had reached a comfortable plateau, but new growth did not seem imminent. Perception among many younger specifiers was that the firm, though reputable, was old and stodgy. Howe realized its identity was neither reaching nor connecting with this audience. Reintroducing the company, with a clear and forward-reaching identity makeover could develop one clear brand that would address the two distinct client bases. With a recently appointed president, promoted from within, the time for change was ripe. According to marketing director Robert Zoehfeld, "We needed to send up a flare. We make innovative products. This company is exciting and on the move, but we weren't bringing it to light."

While several design firms were reviewed, Zoehfeld went with a firm he had wanted to work with for a long time. He had met Nancy Skolos seventeen years earlier when he worked as furniture designer and engineer at a Massachusetts furniture company. Nancy, between semesters at Yale, was doing line drawings and working on price lists. There they developed a healthy respect for each other's thoughts on design and way of thinking. It was this way of thinking that Zoehfeld thought right for the job.

Skolos and husband/photographer Tom Wedell had recently completed the groundbreaking design of the *Farrington Guitar* book. A virtual showcase of the S/W

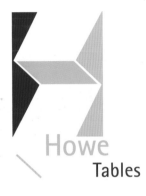

Symbolically linking product and company, the Howe logo presents an optical illusion that simultaneously recedes and advances, folding upon itself.

Below, initial development of the mark.

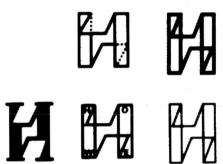

Opposite page, the 20 foot x 20 foot (6 meter x 6 meter) traveling exhibit booth creates an inviting and glowing presence with a well-lit structure of aluminum, fabric, and extraordinary design.

In the background, the logo forms a textile-like pattern on the back of the letterhead.

repertoire of a singular design and photographic vision, it displays a complete harmony with the one-of-a-kind guitars featured. It was that kind of rigorous analysis of product and information coupled with innovative design that Howe demanded.

Though Howe's products—tables —are essentially static, Howe sees their use in the context of bringing people together. The tables fold or have tops that flip down rapidly for many uses, making rearranging a room for training sessions or clearing them for exercise a quick and effortless process. Howe president Eric Smith, a member of the Young Presidents Organization, wanted the corporation to be perceived as "high-energy."

Their first teaming was for Neocon, the leading industry trade show held annually in Chicago's Merchandise Mart, a center of industry showrooms. Skolos relates that Smith, "said he wanted it to be 'like Nike, like Niketown.' We said, 'Are you sure?' He said, 'Yes.' He was ready for something that would have a lot of impact, that was challenging." Skolos and Wedell, both architecture and furniture mavens, had attended Neocon for years and understood the market and the impact to be made.

Skolos found a way to downplay the existing logo, a "fat, squashed-together Univers, with a fat rule underneath," by using the font in outline form, and then silkscreening that onto neon plexiglass—the materials and color becoming the visual charge. Skolos/Wedell had done some interior design before, but had never specifically designed trade show or exhibit spaces.

With no rigid identity manual or set corporate colors, the logo has been printed in several combinations. The letterhead palette of pale green, pale orange, and dark blue provides a point of departure. Concern for being environmentally friendly—Howe uses eco-friendly coatings—was an easily met criterion, using recycled papers and soy inks.

Binder divider pages, right, reinforce the flexibility of the logo with the Skolos/Wedell version of *Nude Descending a Staircase*, printed in olive greens on a heavily flecked stock.

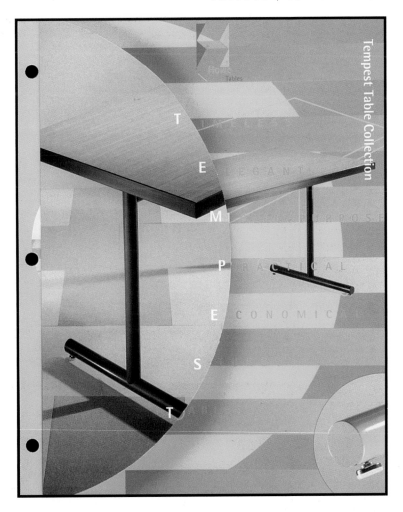

Tempest Table Collection

Otl Aicher's Rotis was chosen for the logotype, as well as for all other text, due to its extensive family of serif, sans serif, semi-sans, and semi-serif versions.

The product brochure for the *Tempest* line, at right and below, caused a stir among salespeople, but generated favorable client response.

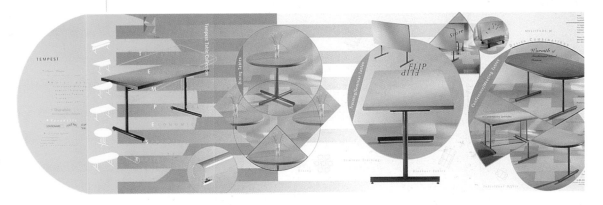

S/W specified tables built in a "crazy" color palette with leopard-print and green-and-yellow snakeskin laminates. The newly colored tables—some actually designed between ten and twenty years earlier—created a sensation. Designed by renowned product design consultant Niels Diffrient, they flew in the face of Diffrient's subtle palette of grays and earth tones. "He looked like he wanted to strangle somebody when he first walked in the showroom," said Skolos, "But after the first day, it was getting so much attention and his products were getting so much attention—people thought they were new products. Niels wound up liking it in the end." And so did customers, who visited the bold, bright showroom in droves.

With the success of the initial booth, Howe presented S/W with a twenty-page description of what they wanted in a complete overhaul of their identity. The design firm didn't present an outline or proposal of their own, for, as Skolos says, "My best strategy is to listen closely to the problem as it is presented and respond as quickly as possible with a range of visual concepts for their evaluation and feedback."

Buzzwords fly about any industry, and the words *transformability*, *flexibility*, and *lightweight* have become part of the vocabulary at Howe, reinforcing their concept of tables "on the move." From the start Skolos intended to "breathe a more architectural look into it" and, playing on the buzzwords, create a mark and identity that took on those characteristics.

Much of Skolos's design process

Integrated Plans;

Incremental Growth

ACCORDING TO MARKETING Director Zoehfeld, there are two factors when considering the long-term plans for moving any company forward. The first, developing an integrated business plan, involves all aspects of product development, marketing, and sales.

Making the most of a new product introduction requires consideration of factors that should be carefully synchronized. Product literature, customer service, and product supply must be coordinated so that all are delivered as promised.

Over-promising in sales literature will backfire. Conversely, good products with ill-timed marketing materials will never leave the factory.

Incremental improvements to products or services are paramount, and that only comes from analytical insight into the nature of one's business. Marketing and design has to respond to those changes. As designer Skolos points out, "It takes a while to truly understand a company. Recent work shows the result of our several years' experience and immersion in the company."

For Howe Furniture, and in turn Skolos/Wedell, the combination of integrated plans and incremental, evolutionary change have seen results that have definitively increased market penetration.

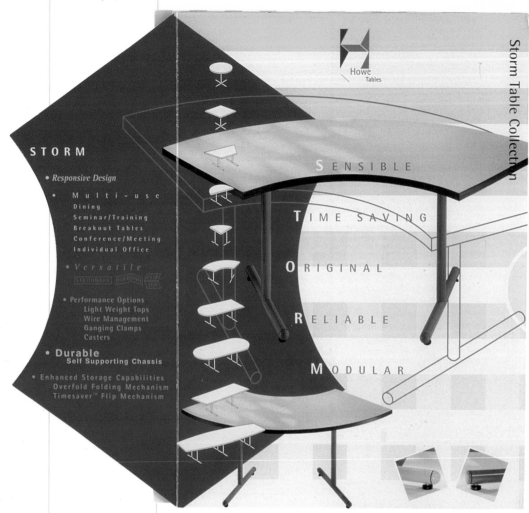

Above and right, the *Storm* collection cover, with flap open and closed. The die-cut flap reveals information bullet-points and schematic drawings of the tables.

involves sketching, but this time she went directly to the computer, working in an illustration application, as it was clear that manipulating several letter-forms and analyzing the shapes that emerged would hold the key. Skolos worked on the mark off and on for what she considered a lot of time—five or six weeks—not leaving it until the last minute. While in crunch mode finalizing the mark, Skolos's mother came to visit. Mom wanted to visit an out-of-state casino. In the back seat of the car, Skolos worked with her laptop computer, finding a parallel between her mother playing the slot machines and

Skolos playing with letterforms, both hoping to hit the jackpot. Skolos did, by pulling the counter forms of the letter *H* sideways.

The mark she'd been working on became definitive, evolving into a form

blocks in place, Skolos/Wedell next designed a 20 foot x 20 foot (6 meter x 6 meter) traveling exhibit that would debut at Interplan, a major trade show at New York's Javits Center. With help from fabricator Ian Tesar, of Robins

marketing directors.

With the trade show exhibits and displays generating increasing interest, rolling out marketing materials and sales kits became the next focus.

Howe's tables are used in fairly

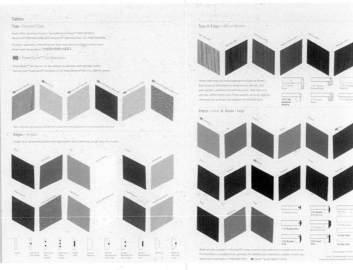

Above, the simple color specification chart uses shapes that are neither gratuitous nor arbitrary and reflect the corporate identity,

both simple and complex. Fundamental qualities of the products' modular and stacking efficiency became evident in the seemingly simple form.

For their business papers, Howe wanted to make an impact with a four-color letterhead, with the stipulation that it not be boring. Skolos's trademark ancillary details are apparent, but downplayed on the letterhead, nevertheless stretching the boundaries of a solid, corporate look. The marks on the front are in reference to the textile-like pattern printed on the back. The distinctive patterning of Strathmore Paper's *Elements* line plays a supportive role in the letterhead and brochures, adding another design element.

The fundamental identity building

Tesar, a firm that had built many of Howe's booths over the years, the buzz-word "lightweight" drove much of the design concept.

An aluminum frame was constructed, over which slipped a fabric cover. Wedell, who as a photographer regularly uses lighting to project a variety of moods in his work, strategically placed lights within the booth, creating a dramatic and glowing presence. In an uncharacteristic moment, the self-effacing Skolos stated, "It was by far the coolest thing in the Javits Center." According to Zoehfeld, the theatrical display drew in more than three thousand visitors, garnering rave reviews from a number of competitors' presidents, product managers, and

generic settings: schools, function rooms, hospitals, cafeterias, seminar training rooms. But working to retain the newly acquired or awakened audience, Skolos/Wedell continued to build on color and shape configurations, using those elements for lavishly kinetic layouts and photography. Brochures for the most generic tables have become the most stylized and invigorating.

Sales did go up with the introduction of the *Tempest* brochure, but the innovative, frenetic layout proved difficult to use for tradition-minded salespeople, who found it chaotic. Their response: tame it down.

Subsequent brochures have been designed following the mandate to create work that's "tame, but not lame."

This direction has worked well, as seen in the brochure for Diffrient's latest line, which has been toned down, letting his vision take the forefront.

For Skolos, putting her spin on the design is as valid as any other approach, as the intention has always been to

etc. Howe now realizes to achieve specific results they have to give the studio equally definitive goals.

This thoughtful evolution, whether in product design, marketing plan, or design strategy, is the sign of healthy and robust company that can

solve for a single client and it was a good chance to prove to myself that I have matured as a designer and design director.

"I've become a lot more focused on solving the client's problems and thinking about the audience, marketplace, and context of the piece. This is something Tom and I have learned from teaching at the Rhode Island School of Design. They place such a strong emphasis on 'making meaning,' on being aware of what means something to a particular audience."

With unheard-of frankness, Skolos says that element was missing from their work. The work was more about Tom and Nancy's vision. "That wasn't totally wrong back when we started the studio because there was so much boring work going on and there were so many conventions that needed challenging. We've discovered (better late than never) that you don't have to sacrifice your vision, you just have to learn how to channel it to a purpose. The Howe project allowed us to realize how this can work."

"Working with Robert was the best part of the project, as he had so much faith in us. It is an unusual relationship. Politics are usually involved in undertakings like this. Half the time the feedback isn't based on the work itself, but on who wants to look important. If that was going on, he sheltered us from it. He is a creative person himself, so he understands the best way to get the most from creative people."

The ability to be forward-thinking and take calculated creative risks has let Howe reaffirm its position as its market leader.

An underlying 3/4 inch (20 mm) horizontal grid is the primary structure on which components are built. Vertical placement is, more often than not, done intuitively.

encourage interior designers to be creative with the tables and their use. Zoehfeld is quick to praise the analytical methods of Skolos and Wedell, pointing to their understanding of human response to sequence and space.

The original scope of the project focused on shape and color. For the latest product brochures the Howe team provided a precise outline for content and focus, marketing by means of function: office, conference, seminar,

confidently move forward.

Skolos reflects upon the scope of the project and the influence it's had on her professionalism, "This project is the best overall opportunity I've had in my career. So many of our projects have been one-shots: posters, books, brochures, and small identities. The Howe project has been like a graduate thesis from the past fifteen years of practice. It is rare to be offered such a comprehensive range of design problems to

The second version of the showroom reinforced the introduction of the new literature system, translating the horizontal grid for collateral into a 3-D environment.

DUNN SAFETY PRODUCTS
ESSEX TWO INCORPORATED

Creating a Catalog to
Capture a Market

Dunn's logo
was designed by
Ute Jansen.

CLIENT
Dunn Safety Products
Chicago, Illinois

CLIENT CONTACT
Howard Glick, Managing Partner

DESIGN FIRM
Essex Two Incorporated
Chicago, Illinois

ART DIRECTORS
Joseph Essex
Nancy Denney Essex

DESIGNERS
Joseph Essex, Jennifer Carney

PHOTOGRAPHER
Sandra Miller

DUNN SAFETY PRODUCTS was a small warehouse of industrially related products sold over the phone through a collection of product-specific sales sheets provided by the manufacturers. When Essex Two came on board, the only identity component that Dunn had was a logo. While the logo was solidly designed, because of the nature of Dunn's visual exposure to its customers the mark did not have an opportunity to develop a visual link to the products Dunn sells.

Essex Two created a new positioning for Dunn that developed a service identity for the company, turning them from a small, sleepy distribution center into a very large, sleepless distribution center. The catalog premise, and in turn the new Dunn strategy, is simple: Look like you have your act together.

Most of the materials Dunn represented were grouped by product manufacturer, not by function. This created an unwieldy and confusing sales tool. Dunn's new materials are designed and positioned to be a presentation of prequalified products, placing Dunn in the rank of authority as evaluators and purveyors of quality and service. With their catalogs now having the look and feel of contemporary consumer/retail catalogs, similar to those Dunn's customers may receive at home, their identity has been upgraded to that of a superior service organization providing a broad range of exceptional products to lay and industry customers.

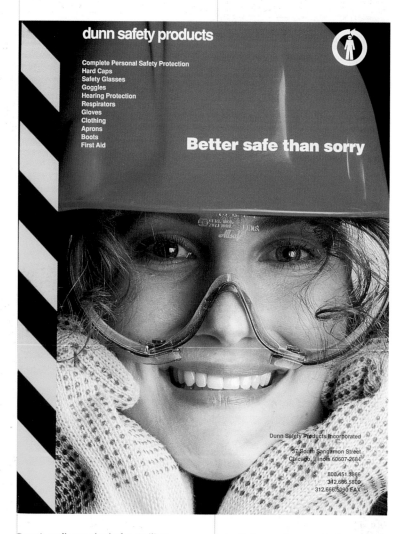

Dunn's earlier method of compiling manufacturer's product sheets in a three-ring binder cost approximately fifteen dollars each, with shipping charges of nine dollars. Printing a catalog along the lines of a retail catalog or an annual report brought the cost to three dollars and fifty cents each, with mailing costs of less than a dollar.

Potentially mundane products are given a fresh face and presented in a visual style that borrows from the world of retail catalog sales, going against industry standards. Actors—not models—were used for the photos, with the belief that the actors portrayed more personality and were easier for clients to identify with.

As seen in the spreads below, a variety of industrial products—aprons, boots, face shields, helmets, and respirators—are given a fresh and appealing look by photographing them with an approach often used for fashion items. Though several items are on each page, the clean silhouettes make for an uncluttered look.

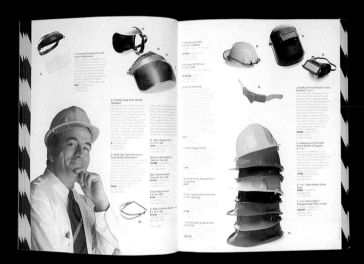

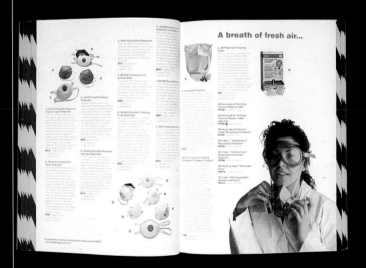

Easy-to-read gray text, set in Univers, looks friendly and avoids monotony by hanging from a number of places on the page. Two black plates were used. The second one contains product code information that may be changed easily to update future catalog editions.

SHAW CONTRACT GROUP
WAGES DESIGN

Consolidation and
a Strengthened Position

The "S" shape is used throughout the identity as a graphic element. Galliard is used for the logotype and prime font. Univers serves as secondary font, though others are used for display purposes.

SHAW INDUSTRIES IS THE world's largest commercial carpet producer. Yet even as an industry leader, they must stay ahead of aggressive competition. A benefit of their size is the ability to produce great quantities. A downside is the perception that industry specifiers' opinions are ignored.

With a dramatic change within the industry, the competition was directly addressing their market with high-end, design-conscious positioning. In response, Wages Design, already working on individual brand materials, was asked to reevaluate the company's binders. With three different looks, the product lines of Networx, Stratton, and Shaw Commercial were sold under brand names only. Wages's recommendation was to consolidate brands under the corporate moniker, benefiting from the Shaw name equity.

Shaw introduced this new identity in a way that repositioned them among specifiers in the architectural and design community, showing they were sensitive to the needs of their market. Actual carpet swatches became key components of the binder—the primary component of their marketing materials—and a direct mail campaign. With an ad about their new positioning on the back cover of *Interiors*, they included a swatch with each shrink-wrapped issue, placing product in the hands of potential customers.

CLIENT
Shaw Contract Group
Dalton, Georgia

CLIENT CONTACT
Mike Gallman, Executive Director

DESIGN FIRM
Wages Design
Atlanta, Georgia

ART DIRECTOR
Bob Wages

DESIGNERS
Rory Myers
Lionel Ferriera

Top, corporate identity standards. Bottom, two- and four-page case studies are used to show examples of Shaw commercial carpet installations in their environment. These include offices such as Continental Airlines and MTV.

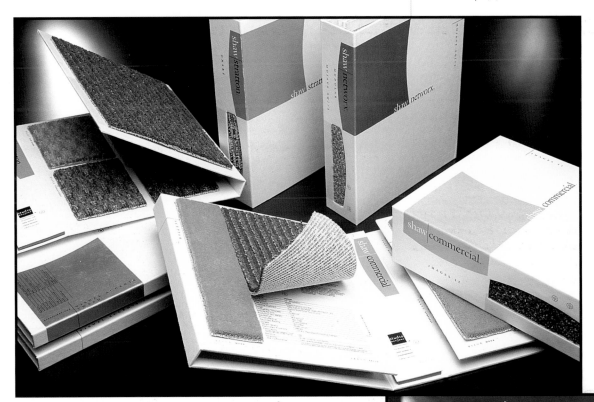

At left, user-friendly sample binders enable specifiers to see and touch carpet samples without pulling binders down and opening them.

Samples were glued and backed with chipboard, "imbedding" them in the spine. In keeping with Shaw's high recycling standards, binders were made to specification with recycled industrial bookbinding papers. The custom paperboard required longer fibers than the typical recycled paper to prohibit cracking when folded. Manufactured in sets of five thousand, they were printed with silk-screened metallic inks.

Left, this early, product-specific capabilities brochure became the model for the entire identity.

External quarterly newsletters employ fashion-conscious photography, case studies, innovative product applications, and a unique die-cut. They're backed with a usable three-month calendar.

LUCIFER LIGHTING COMPANY
GILES DESIGN, INC.

Illuminating
a Point of View

LUCIFER
LIGHTING COMPANY

The logo, previously designed by another firm, was retained, as it had become established within the industry. That said, it was further refined by Giles Design.

LUCIFER LIGHTING COMPANY IS characterized by a contradiction: they're an old-fashioned company—still using a typewriter for correspondence—that manufactures and sells extremely sophisticated contemporary lighting systems. The same contradiction surfaced in their reaction to the work presented by Giles Design. Lucifer's unwillingness to surrender the old conservative look battled with their astute, sincere appreciation for the innovative designs submitted for their approval.

The relationship between studio and client, consisting of a few up and down years, has become a hard-won victory for both parties. When Jill Giles felt mediocre design was being produced due to client nit-picking, she resigned the account. Months later Gilbert Mathews called back asking the firm to move forward. Giles Design made a concerted effort to modernize —slowly—Lucifer's marketing materials, and by doing so, their identity. Each successive catalog has become a little brighter, illuminating a company whose product is brilliantly spotlighted.

As Lucifer's identity has moved further along the axis from conservative to progressive, potential customers have noticed. In 1995, their *Play of Light* ad earned an award from *Lighting Design + Architecture* magazine for generating the most consumer response for the year. Consumers recognize compelling ideas when they see them.

CLIENT
Lucifer Lighting Company
San Antonio, Texas

CLIENT CONTACT
Gilbert Mathews, President

DESIGN FIRM
Giles Design, Inc.
San Antonio, Texas

ART DIRECTOR
Jill Giles

DESIGNERS
Jill Giles, Tyra Simpson,
Stephen Arevalos, Deborah Sweet,
Warren Borror

PHOTOGRAPHERS
Tracy Maurer, Gary Hartman

Above, the corrugated plastic binder was a huge leap for Lucifer Lighting. For a number of years they had provided their clients with a plain, charcoal-gray, cloth-covered binder for product literature.

It took two years to convince LLC to go with the translucent fluted cover, which very simply demonstrates qualities of light and shadow.

The gradated yellow on the inside of the binder further reinforces the idea of luminescence.

Exaggerated and stylized photography
has played a key role in depicting the
quality of light and, in turn, focusing on
the products themselves.

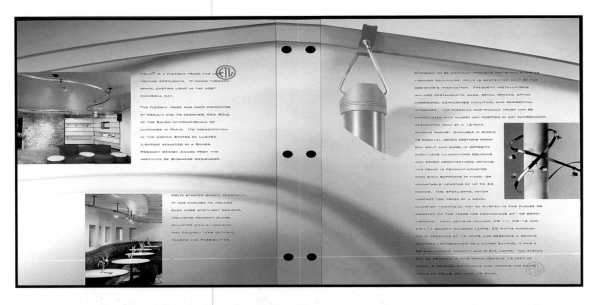

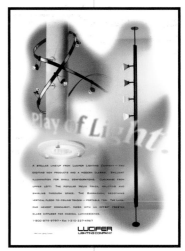

Above, trade ads
generated tremen-
dous response
while showing
multiple products
in a simple way.

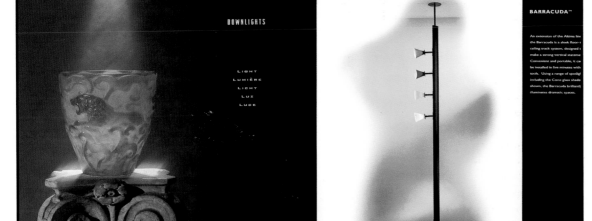

CALUMET CARTON COMPANY
BRAND DESIGN COMPANY, INC.

Bringing Products—
and Businesses—to Life

The Calumet Carton "Triple C" is a simple logo that dates back to the company's roots, more than eighty years ago. Recognizing its sublime qualities, Brand "cleaned up" the mark and reapplied it.

CALUMET PRESIDENT KEN ROUSH was intrigued by the design for a CD project that his Illinois plant, a manufacturer and printer of a wide variety of packaging materials, was producing for a Delaware software company. On press were designers Rich Roat and Andy Cruz, who worked in the marketing department of said software company. Roush, seeing a growing market in CD packaging, asked the pair if they would design a promo targeting that area.

Traditionally Calumet had sold and marketed their products through brokers for paper distributors. The new promo saw a 25-30 percent response, most of which had found an avid new audience: designers.

Consequently, Calumet, eager to capitalize on this aware new audience, hired Roat and Cruz—and their newly launched Brand Design Co.—to produce a new corporate identity.

Brand capitalized on the strengths of the company by creating an identity that pays homage to the industrial nature of manufacturing and printing processes. Contrasting the sophisticated look of rich metallic and white inks against stock kraft, Calumet's product is seen as a worthy canvas.

The result has been an increase of in-house design departments and design consultants specifying Calumet's materials for a broad range of end uses, from the high-fashion to the utilitarian.

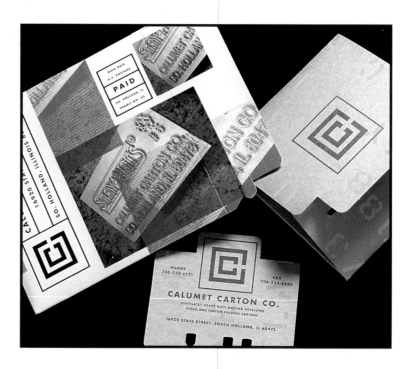

As seen above and right, the sharp contrast of vivid color and metallic ink works well on either kraft or clay-coated stock. Several sans-serif fonts are used to underscore the machine-age feel that runs throughout the pieces.

CLIENT
Calumet Carton Company
South Holland, Illinois

CLIENT CONTACT
J.K. Roush, Executive Director

DESIGN FIRM
Brand Design Company, Inc.
Wilmington, Delaware

ART DIRECTOR
Rich Roat

DESIGNERS
Andy Cruz, Allen Mercer,
Jeremy Dean

PHOTOGRAPHER
Carlos Alejandro

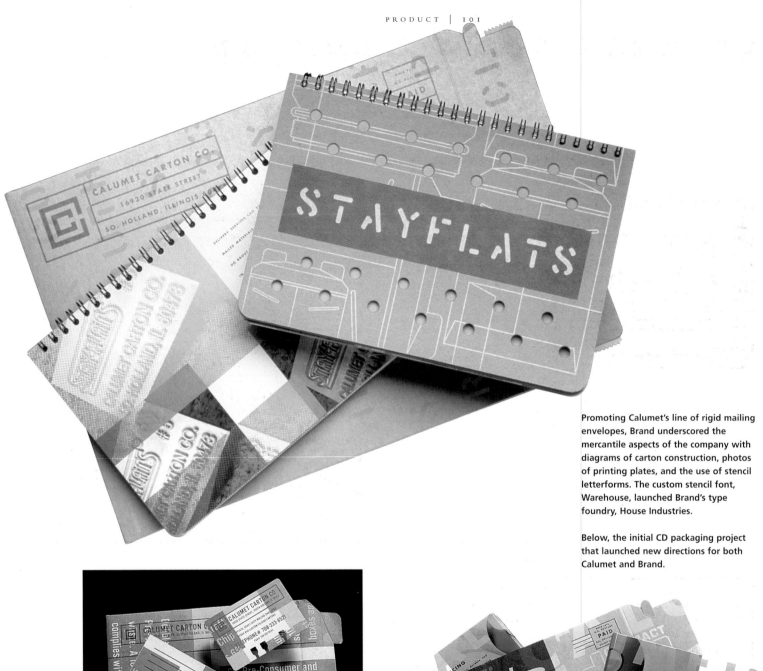

Promoting Calumet's line of rigid mailing envelopes, Brand underscored the mercantile aspects of the company with diagrams of carton construction, photos of printing plates, and the use of stencil letterforms. The custom stencil font, Warehouse, launched Brand's type foundry, House Industries.

Below, the initial CD packaging project that launched new directions for both Calumet and Brand.

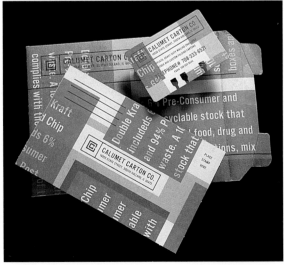

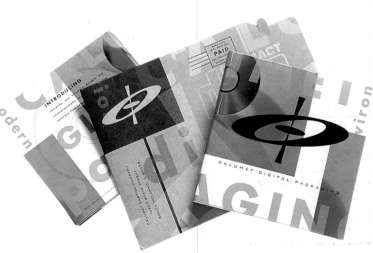

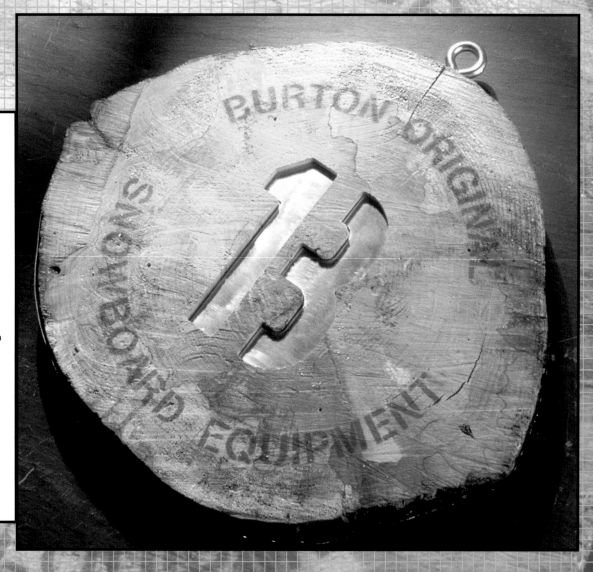

CLIENT
Burton Snowboards
Burlington, Vermont

CLIENT CONTACT
Jake Burton, President
Dennis Jenson, Sr. VP/
 Director of Marketing

DESIGN FIRM
Jager DiPaola Kemp Design
Burlington, Vermont

CREATIVE DIRECTOR
Michael Jager

COPYWRITER
David Schriber,
 Creative Services Director, Burton

DESIGN DIRECTOR
David Covell

DESIGNERS
Jim Anfuso, Keith Brown, Elizabeth
Grubaugh, Adam Levite, George
Mench, John Phemister, Dan Sharp,
Mark Sylvester

PRODUCTION
Pat Drislane, Ken Eiken, Karrie Hovey,
David Mendelson, JeanMarie Norton,
Steve Redmond, Jill Webb, Ed Wilbur

BURTON SNOWBOARDS
JAGER DIPAOLA KEMP

Carving a Niche

in the Market

**THE PURSUIT OF HAPPINESS IS OFTEN MANIFESTED
in recreation and leisure. Accordingly, businesses in those areas have
grown monumentally and, along the way, created cultures of their**
own. A case in point is snowboarding.

Snowboarding grew not from skiing but from surfing and skateboarding, as
witnessed by the late-1970s "Snurfer," a single ski with a tether at its nose. In 1977,
the teenage Jake Burton was creating rudimentary boards and tethers of his own.
Today Burton Snowboards is the leader in snowboard design and manufacture, in a
$700 million industry, with offices in the United States, Austria, and Japan.

In 1989, Burton contacted the Burlington, Vermont–based design studio of Jager
DiPaola. The four employees, headquartered in the basement of Michael Jager and his
wife, Giovanna DiPaola, came to their attention for projects in the ski industry and
action sports. Since then the design process has come a long way. Early on, Jake
Burton held an annual Oktoberfest for his employees, hard-core riders and
pro-boarders connected to Burton. At the party, he would display board graphics
submitted by five or six designers for review. According to Jager, "in a late-night haze
[they would] determine the board graphics for the next year. It was entertaining but
also frustrating if you were actually a 'committed' designer."

Both firms have grown up together. Coherent approaches and brand consisten-
cy have developed along with the relationship between client and studio. "Board
graphics lead to T-shirts, stickers, catalogs, packaging, and discussions about boot and
binding colors. We ended up affecting everything about the brand right down to their
building and store, which was an incredible design opportunity," notes Jager.

In the early days buzzwords like "brand" and "corporate identity" were not part
of the design team's vocabulary. Instead, they were interested in Burton's "voice."
Design director David Covell states client and studio were more interested in
"anti-brand." "We started off being very conscious about how Burton would grow.
Burton seemed to grow a lot faster than other snowboard companies. They were
really nervous about that, because there was obviously the stigma of 'if you were big,
you were corporate and if you're corporate, you're mean and you don't care about the
small guy.' And that definitely is an attitude that a lot of young snowboarders and
skateboarders had. So we were [all] very conscious to downplay the very speedy
growth of Burton."

Jager adds, "a lot of brands in the youth-culture scene 'burned their brands.'
They did too many things too quickly, selling anything they could stick their logo on,

At left, the latest
corporate mark,
for internal use
only, designed
in 1995.

At left, the
"Air Disk" mark,
created for a line
of snowboards,
became so popular
among hard-core
riders that a few
sported tattoos of
the mark.

Upon presentation
of the "B-13" mark,
in 1993, the JDK
team noted the
resemblance it
bore to a spray-
painted stencil on
a rudimentary
Burton prototype.
The "B-13" has since
been seen in a
variety of styles,
including a
rendering in bacon.

which is exciting at first, and then people get burned on the brand and they won't touch it. We were very, very leery of that happening to Burton."

Both Burton and Jager DiPaola were adamant about not falling into the trap of burning a hot product to the ground. Burton focused on product alone: snowboards, boots, bindings, and snowboard clothing. JDK took a series of steps to keep the identity vital by constantly changing the wordmark, the type, the concept, the graphic, the attitude. The platforms of catalogs and ads completely changed, flying in the face of traditional identity. "A different run down the mountain" became the studio mantra. The team approached each project as a challenge unto itself, never doing the same thing twice.

When Jager DiPaola became part of the Burton design team, the Burton wordmark consisted of all-caps, letterspaced Helvetica Bold, within a black bar. Designed by David Carson, that logo saw its last push in the frenetic 1992 catalog. In reaction to a lot of the slick computer work of that time, JDK approached the graphics with handcropped photos, text, and photocopied images. A pivotal development that year was the introduction of the "Air Disk" mark, for the Air series of boards. That started a trend for an iconographic platform, which sprang up on a few different products.

Lingering longer than most Burton graphics, the Air Disk evolved from a circle to an ellipse to an eroded shape. The disc was so well

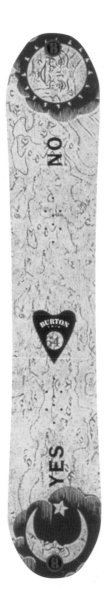

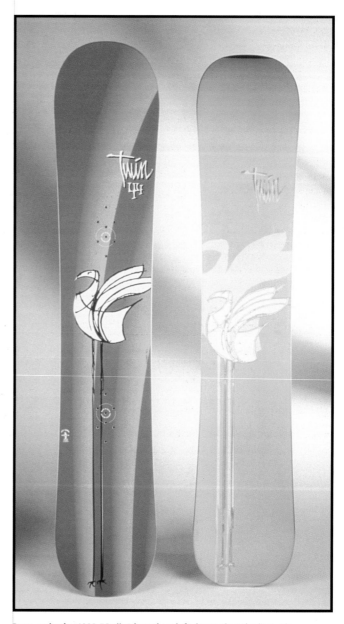

Puns, as in the 1992 "Ouija" board, at left, have played a key role in Burton's friendly approach to design. Board design for the 1996 season, above, while still showing wit and whimsy, has moved toward a cleaner, more streamlined look, consistent with Burton's position as forward-thinking technical innovators.

BURTON **burton**

Above, a variety of wordmarks include a crumpled iteration of the early mark designed by David Carson, far left.

For internal purposes only, the new Burton identity, separated from sales and merchandising, helps create unity for the international offices. At top right, the old stationery system. Below right, new design standards emphasize precision as they push the envelope, as noted on the swooping #10 die-cut, at lower right.

LETTERHEAD FORMATS

embraced by hard-core riders that some were seen sporting tattoos of the mark.

The 1993 catalog, dubbed the "science book," became another pivotal point. At that time many snowboard salespeople were kids who embraced the sport. Industrial strength charts, graphs, and text treatment provided the measure of informative data the budding salespeople required. Witty "pop-quizzes" added surprise and entertainment.

That year, while trying to come up with a symbol that could be used consistently and yet have some measure of ambiguity, the "B-13" stencil was created. The mark went off without a hitch, and JDK has since created several variations on the "B-13" theme, giving it wings, and rendering in both neon and bacon(!).

The full cycle of developing board graphics has moved well beyond Oktoberfest one-shots. Round-table discussions, research, development, color-forecasting, graphics, type and illustration, production, processing, print proofing around the world, and final approval take a year to complete.

In 1989 Burton manufactured a half-dozen boards that were displayed in a sixteen-page catalog. Today Burton produces more than sixty-five snowboards per season, with annual consumer and dealer catalogs, a variety of advertising, and several smaller projects. Keeping pace with their client, Jager DiPaola Kemp (David Kemp joined as market-ing director in 1992) now has a staff of forty-five. The lion's share of the Burton work falls to an eight-person team reined in by Covell. They in turn are

Keeping an Identity Alive

"THERE IS A STRONG MISCONCEP-tion that if you can create a good mark and identity, then success will follow," says Senior Vice-President and Director of Marketing, Dennis Jenson. Much of Burton's success lies in having a very clear plan internally and working with a design team Jenson believes "has helped create a feeling of constant evolution and change within product categories."

With some two-hundred competing brands on the market, maintaining perception of core brand equities is critical. Skillful image maintenance ensures Burton isn't perceived as confused or lacking direction.

Graphic styles vary from year to year, based on close contact with the consumer base. Understanding music, fashion, and basic attitudes goes a long way toward anticipating the look of the new product line and graphics. This is seen in transi-tions from visceral images inspired by an "us against them" disposition reacting to skiers, through the "scientific" phase, to the recent Utopian approach. The latter, inspired in part by the "rave" music scene, exudes an aura of inclusion and peace, light-years away from earlier materials.

Unexpected design keeps the components that add up to the Burton identity refreshing and alive. Jenson quotes Jager, "the minute people can tell what you're gonna do, you're dead."

Attitude has always been a selling point in Burton advertis-ing. Early ads, at right, take an in-your-face approach.

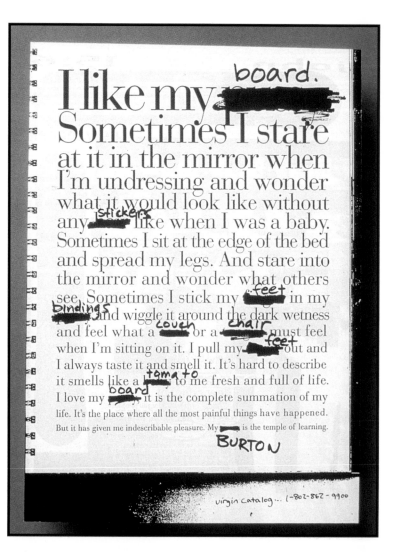

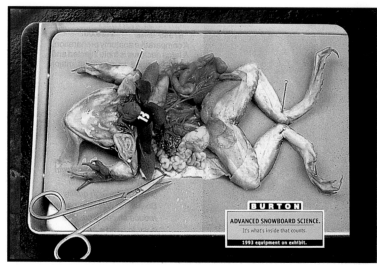

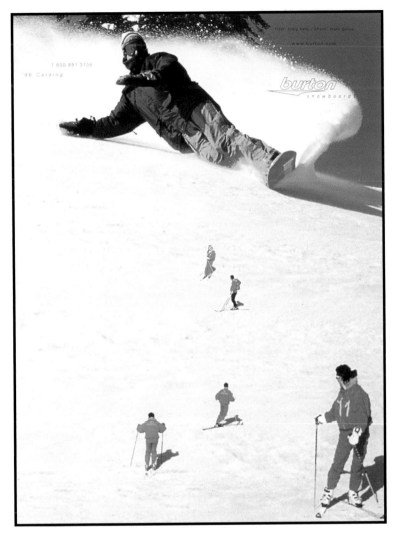

Recent ads, at left, rely on equally succinct copy (printed in partial-reverse on the ad at bottom) or satire. The coincidental "homage" to Swiss ski posters, top, owes more to *Godzilla* movies than to design history.

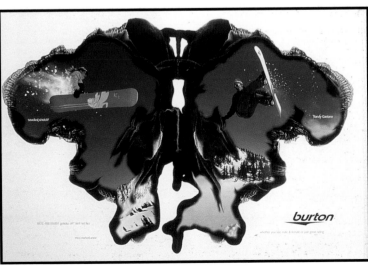

supported by two creative services people, who handle production, and three account services people, who provide research, organize schedules and timing, and make sure projects meld together worldwide.

From the very beginning Burton Snowboards has been about change. Similarly, marketing strategies at Burton have grown and changed, as its audience has grown and changed. That may seem simple on its surface, but one must consider how that audience has changed.

Dealers who once had little shops in their basements now have trade show booths in Las Vegas. The small cult of riders that found an alternative to the perceived elitism of skiing has grown into a sophisticated culture that now cares as much about precision gear as any other athlete.

Burton's positioning has always maintained a sense of corporate irreverence, a hallmark of anti-establishment thinking that every generation has at one time or another embraced, and one that has maintained the firm's street credibility. The flip side of the coin is Burton's credibility as a technical manufacturer seriously committed to the use of design and technology to modify product lines in the pursuit of ideal equipment.

"It's a trademark of Burton to listen," says Jager. "They never stop listening to the marketplace. That's critical . . . It's dangerous if you use research to 'give' you the answer. That usually ends up as a pretty milquetoast solution." Always on the move, solutions have taken the client and studio from

early industrial references of board production to rough-hewn backwoods authenticity and to a clean, sophisticated, brighter Utopian aesthetic.

Burton and JDK put a face on an international corporation. Their audience knows they are real people, interested in people and product, and it shows. Jager sums up the experience of designing for a client who cares: "It's all about the people. If you don't have people that respect the design process or you can't respect what they're doing on the marketing side, you will do poor quality graphic design. If you can connect and hit it right, you can make magic."

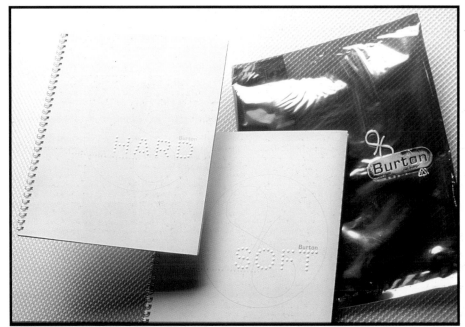

The catalog design treatment sets the tone for the upcoming season. Regardless of style, Burton takes the position of pioneers, whether in the backcountry or in technology. The '94 catalog, opposite page, featured a marmot on leather-finish stock, hand lettering, and wooden plaques. The '96 "White Album" catalog, top, is replete with streamlined graphics, a rich array of blissful colors, custom typeface, blind embossed cover, and mylar wrap.

ALEEDA WETSUITS
13TH FLOOR

The letter *A* in a truncated oval became a natural focus for the logo, much like Superman's trademark. The custom font designed for the logo and wordmark is used nowhere else.

Supporting type is set in Akzidenz Grotesk, Ibsen, or Jodrell Bank, highly legible fonts, not soon to be confused with the plethora of trendy, and soon to be outdated, typefaces plaguing the competition.

CLIENT
Aleeda Wetsuits
Newport Beach, California

CLIENT CONTACT
Steve Terry, Owner

DESIGN FIRM
13thFloor
Manhattan Beach/Monte Sereno, California

ART DIRECTOR
Eric Ruffing

DESIGNERS
Eric Ruffing, Dave Parmley

A $2 Million
Cottage Industry

WHEN NEW OWNER STEVE Terry took over management of sixteen-year-old Aleeda in the early 1990s, one of his first decisions was to bring on 13thFloor as design consultants. Not only were 13thFloor partners Eric Ruffing and Dave Parmley experienced surfers and designers, but both had gained plenty of wetsuit experience from its prior stints working for O'Neill, the industry leader.

Aleeda's goal has never been to be the largest manufacturer of wetsuits, but to maintain its core loyalty and reinforce their image as surfers making wetsuits for surfers. With no marketing directors or product managers, the twenty-person Aleeda looks to outside sources to provide expertise in those areas. 13thFloor was retained to rework an identity that never had one distinct look. Though most surfers don't want to be walking billboards, competition among suit manufacturers determines that the company logo will go on the chest as the key graphic. While surfers will not buy a suit based on graphics alone, they certainly are not going to buy one they find unappealing. Owner Terry, a long-time surfer, is happiest when the logo is smallest, in direct contradiction to many business owners who prefer their mark front, center, and big. The ephemeral world of fashion reared its head long ago in surfing, yet the maintenence of a recognizable identity is still key to brand loyalty.

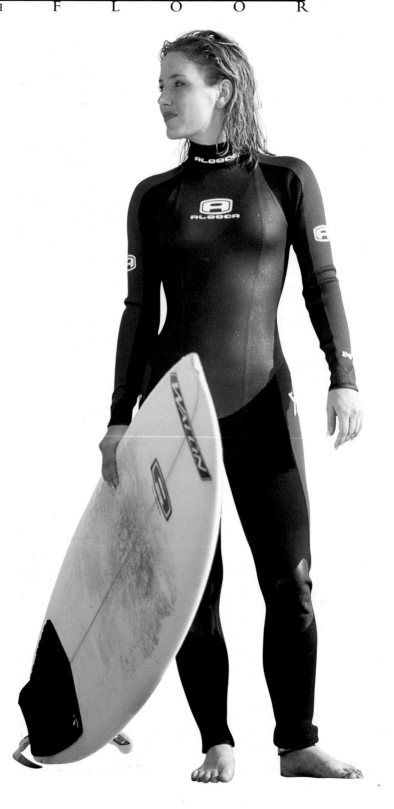

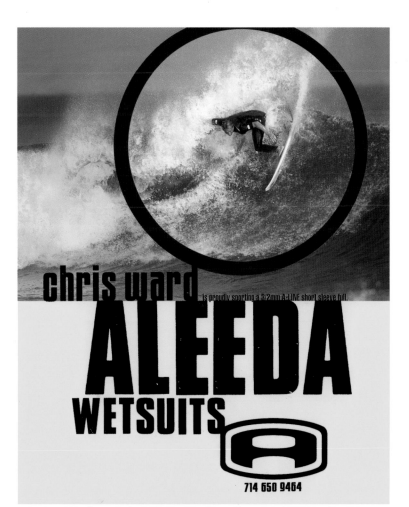

At left, trade magazine advertising is light on text, but heavy on the seal of approval by experienced surfers.

Location photography appeals to the client who often recognizes the photographer's work and seeks out the location.

As in the poster below, action photography is paramount. The idea, to get the readers to say to themselves "did he pull that off?" or "I'd never do that, that rider's insane!" Surfers are very exacting: a weak shot won't be looked at twice.

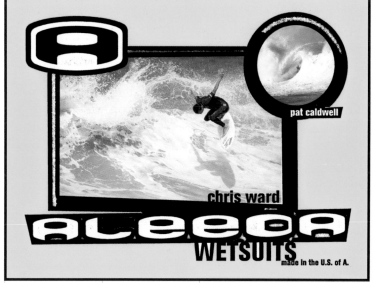

Far left, logo and logotypes are seen applied to chest, neck, biceps, wrist, and hip locations. Because of the wide range of color combinations available in the wetsuits, a universal color scheme of white, gray, and red was adopted for consistency of logo applications.

All artwork on wetsuits is applied as heat transfers. The advantages are ease of application and removing the need for a silk-screen station. With a variety of transfer styles and sizes on hand, placement can be at the discretion of the client and design team.

Inherent problems are reproduction of fine detail at small sizes, expense, and registration of multiple colors.

Left, the product brochure, has to appeal to the four-teen-year-old grom as well as the mid-dle- aged soul surfer. Product details are kept to a minimum as most surfers prefer to get in the shop to try on wet-suits and get details from sales people.

All sales and marketing materials are what 13thFloor calls "pure." No hype; just the facts.

MINNESOTA TIMBERWOLVES
THE MEDNICK GROUP

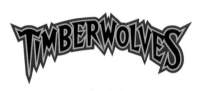

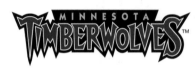

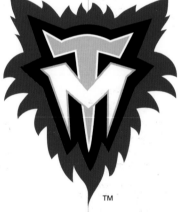

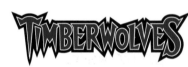

An Aggressive Identity
On and Off the Court

While many firms demand a dynamic logo, "aggressive" was the buzzword for the 'Wolves.

A deliberate aim was the logo's ability to break down into several forms or partial marks that could represent the team as well.

REVITALIZING THE IDENTITY FOR a team that is less than a decade old was a shrewd decision for the Timberwolves. With ambitious new management and news reports of a potential move out of state by the team, the new identity became a symbol of renewed commitment.

A working triad was formed between the 'Wolves, NBA Properties—who own all licenses and rights to the identity—and The Mednick Group, who had worked with new president, Rob Moor, while he was with the L.A.Kings.

"In creating the new logo, we wanted to mirror the aggressive attitude our new front office was looking for," said Brendan Finnegan, Timberwolves' art director. Consulting with many Timberwolves execs, including Head Coach Flip Saunders and Vice President of Basketball Operations Kevin McHale, they came up with a new logo that retains familiar elements from their previous mark, while presenting a bolder, fiercer image.

Merchandising is a billion-dollar industry for the NBA, the NFL, and Major League Baseball. By creating a mark that can be deconstructed, a wide range of applications pleases both fans, who are proud to display the team's colors, and merchandisers eager for sales.

The team, the league, dealers, and ultimately the fans have all enthusiastically embraced this winning identity.

The new logo consists of several components that can also be used alone, such as the wolf's face, eyes, or logotype. In addition, the Timberwolves' corporate identity system includes a secondary mark: a shield in the outline of a wolf's head containing the team's monogram.

CLIENT
Minnesota Timberwolves
Minneapolis, Minnesota

CLIENT CONTACT
Rob Moor, President,
 Minnesota Timberwolves
Charley Frank, Executive Director
 of Communications,
 Minnesota Timberwolves
Tom O'Grady, Creative Director,
 NBA Properties

DESIGN FIRM
The Mednick Group
Los Angeles, California

CREATIVE DIRECTORS
Scott Mednick, Ken Eskenazi

DESIGNERS
Peter Thornburgh, Tom Thornton

LETTERING
Peter Thornburgh

In addition to the fierce-looking wolf on the uniform shorts, McHale suggested the use of trees as trim. Even the numerals used on team jerseys have a razor-sharp aggression.

"The main concept for the uniforms was to keep them simple," said President Moor. "We really wanted them to be striking and that means to choose your shots. If you're going to put one thing from the logo on the uniform, make sure it is really striking and then leave it alone. So that was our approach: create a set of powerful marks so we only needed to use part to communicate our identity."

COYOTE LAKES
RICHARDSON OR RICHARSON

COYOTE LAKES

The conceptual elements of the trademark are both the Southwestern/ American Indian design of the coyote itself— somewhat like area petroglyphs—and the tail of the coyote, which forms a fish, as homage to the project's featured lakes.

CLIENT
Coyote Lakes Community/
 Lakepoint Development
Surprise, Arizona

CLIENT CONTACT
Michael Brown, Developer

DESIGN FIRM
Richardson or Richardson
Phoenix, Arizona

CREATIVE DIRECTOR
Forrest Richardson

DESIGNER/ILLUSTRATOR
Robert Diercksmeier

FAKE COYOTE PRINT
Bill Richardson

Carving an Oasis on Par with a Community

TO MANY, GOLF IS MORE THAN a pastime—it's a way of life, as seen in this master-planned community located outside Phoenix, Arizona. Brought into the project at an early stage was Golf Group, Ltd., a golf course architectural firm run by part-time graphic designer, Forrest Richardson, who since 1985 has been splitting his time between golf course architecture and graphic design.

The objective of the development was to create a small residential community centered around an eighteen-hole golf course on the sand dune banks of the Agua Fria River, a dry wash running through desert terrain. Important were the aspects of a simple, easy-to-recognize image, a natural-feeling identity, durability in terms of material choice, and flexibility for the myriad of merchandising opportunities the golf operation would have working with the multitude of golf clothing companies that supply products to golf pro shops.

Of the client's choice of names, the design team concluded that "Coyote Lakes" was a positive name that related well to the series of three smallish lakes that form the area's core. The trademark choice also was narrowed to that of a coyote, with the ultimate decision made for a leaping, moving coyote, which helped reinforce the progressive, never-static feeling the developers planned for the community.

Cloister, slightly extended, was chosen as the main trademark type, while the regular weight is used throughout the collateral material and text-based applications. The choice of Cloister was made to complement the streamlined logo and appear as substantial and timeless as possible.

Laminated golf course architectural plans, signed by the course designers, serve as restaurant menu covers. Also seen at right is a rusted steel signage prototype.

Colors are all natural, subtle and reserved. Browns and greens were used primarily throughout the scheme.

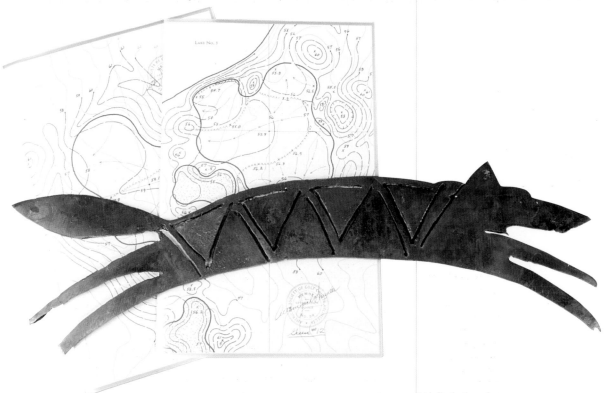

At left, the lay of the land is outlined nicely in this detailed topographic course map. Witty writing offers hole tips . . . "At all costs stay away from the desert island separating the fairway. Marlin Perkins once filmed a *Wild Kingdom* segment in here. It's no place for golf."

COYOTE LAKES
GOLF CLUB

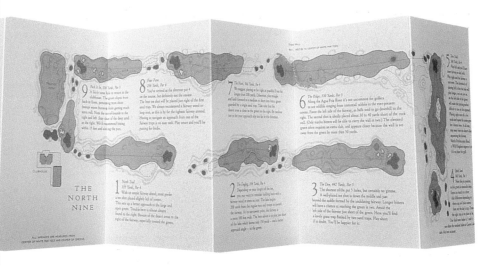

CARTS ▶

At top, pan channel constructed letterforms on an adobe-style wall.

Signs, left, are aluminum panels mounted on rough-cut wooden posts.

At right, putting green pin markers go beyond the ordinary.

Coyote pawprints are embedded into simulated flagstone, far left, for use as tee markers.

Course signage, above, is made of 1/4-inch (.5 cm) steel scrap metal plating, torch-cut in rough-edged pieces and then applied with smaller bits of metal to form pictographs of each gold hole in relief form. The signs are mounted on simple bases cut from scrap utility poles, resulting in an extremely durable and low-cost solution.

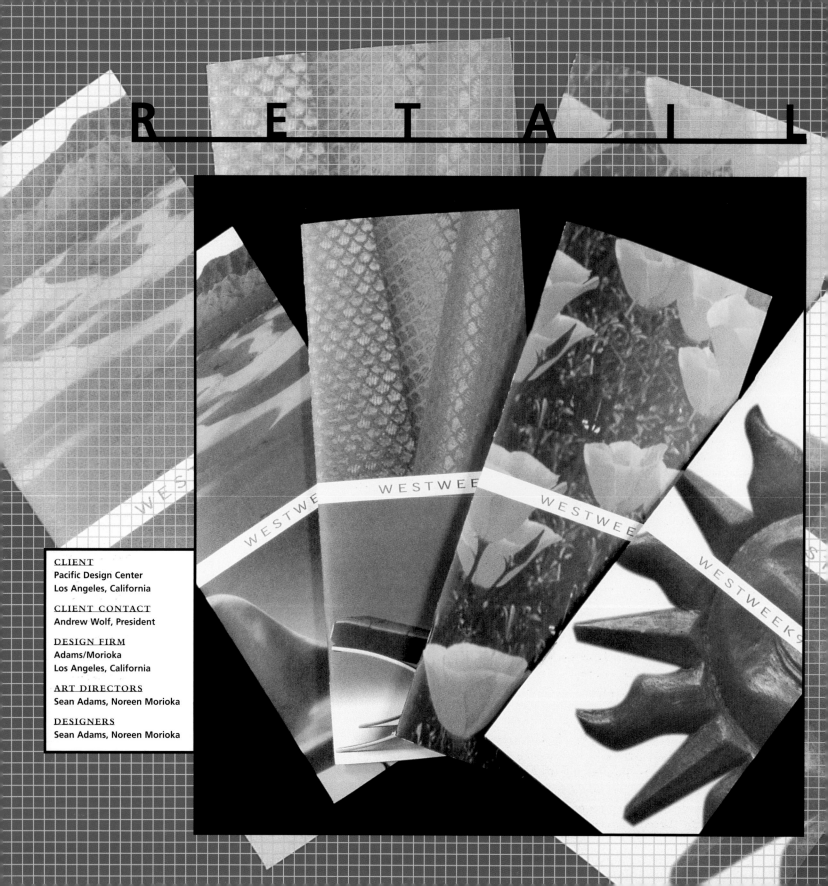

RETAIL

CLIENT
Pacific Design Center
Los Angeles, California

CLIENT CONTACT
Andrew Wolf, President

DESIGN FIRM
Adams/Morioka
Los Angeles, California

ART DIRECTORS
Sean Adams, Noreen Morioka

DESIGNERS
Sean Adams, Noreen Morioka

PACIFIC DESIGN CENTER
ADAMS/MORIOKA

Broadening Horizons to
Revitalize an Area Landmark

FOR TWO DECADES THE PACIFIC DESIGN CENTER (PDC) has served as the central point for residential and commercial furnishings in the Los Angeles metropolitan area, open exclusively to interior designers, builders, and other trade professionals. Over the past few years, a national recession, the PDC's waning reputation as the industry leader in current trends, and the lack of renewed leases from showroom tenants, posed serious problems. To outsiders, the oversized blue and green buildings were intimidating due to scale and inaccessibility.

To revitalize the PDC, the developers who owned the facilities brought in Andrew Wolf, lawyer and former consultant for art cultural issues at the United Nations Environment Program, as president. His charge was to sharpen the focus of the Center and return it to profit-center status—quickly. Wolf drew motivation from a statement made by Louis Gerstner, who had been brought in to resurrect IBM: a company must do "three simple things: focus outward on winning in the marketplace, execute its plan with a sense of urgency, and work more as a team."

A clarification of purpose became essential for the PDC. Conveying the scope of what is held within the big blue and green walls to both contract and public audiences required two prominent changes. The first, opening the Center to the public. While focusing on industry professionals remains the core source of business, allowing access to an untapped market could boost both sales and an overall interest in the Center. Economically, keeping their doors closed to the public no longer made sense.

As a way to educate the public, a concierge service was devised, where an interior designer would be assigned to an individual making specific inquiries into areas such as carpets, curtains, tiles, baths, kitchens, furnishings, etc.

The second challenge, focusing on the Pacific rim as an essential part of their market, seemed obvious as California has long been a convergence of cultures. As Goethe said, and Paul Rand was so fond of quoting, "the hardest thing to see is what is in front of your eyes."

With those changes underway, Wolf next examined the design strategy within PDC. "Graphics quality was my first priority. Why? I spent six years as an assistant to Frank Stanton, president emeritus of CBS. If ever there was a Medici of design in the United States, it was Frank Stanton. He taught me [that] if you don't know who you are through your corporate identity, you don't know who you are as a company."

Sometimes being in the right place at the right time does happen. The Los Angeles Chapter of AIGA (American Institute of Graphic Arts) regularly holds

パシフィック・デザイン・センター

Centro de Diseño del Pacífico

Pacific Design Center

太平洋設計中心

Centro de Diseño del Pacífico
Pacific Design Center

パシフィック デザイン センター

太平洋設計中心

Pacific, designed by Adams, is based on Bell Gothic and serves as the primary Roman font for English and Spanish. Minchoh is one of the first foundry typefaces drawn to resemble the kanji-style Chinese/Japanese brush script.

Trade Gothic was specified as the secondary typeface for corporate materials, with Monotype Baskerville used for marketing collateral.

Opposite page, four covers for one program guide.

Pacific Design Center

太平洋設計中心 Centro de Diseño del Pacífico パシフィック・デザイン・センター

meetings at the PDC. Wolf, in his new role, stopped in on one and met Sean Adams, who at the time was serving as chapter president. Wolf liked Adams and his point of view enough to call the next day and offer Adams/Morioka the project, though Adams had not solicited it.

A management team was quickly established, with Adams and his partner, Noreen Morioka, attending every meeting. The team discussed criteria at length and how those criteria would be visually achieved.

A beautiful mark created by Pentagram's Kit Hinrichs existed before the Adams/Morioka team came on board. Yet with Wolf's amended criteria targeting a new generation of designers, the Pacific rim and its markets, the mark was deemed no longer appropriate.

The identity could not be heavy-handed, as the enormous West Hollywood building houses over two hundred showrooms, each with its own identity. "We were trying to build an identity that functioned as a foundation," says Morioka.

The use of four languages —English, Spanish, Chinese, and Japanese—as the core for the identity makes clear why the building is called the Pacific Design Center, as compared to the Los Angeles or California Design Center. Creating a center of design and culture and manifesting that ideal with a visual solution became the studio's goal. "I look at California, and especially Los Angeles, as a melting pot of one thousand different races and cultures," says Morioka. "What we enjoyed so much about that particular slant was

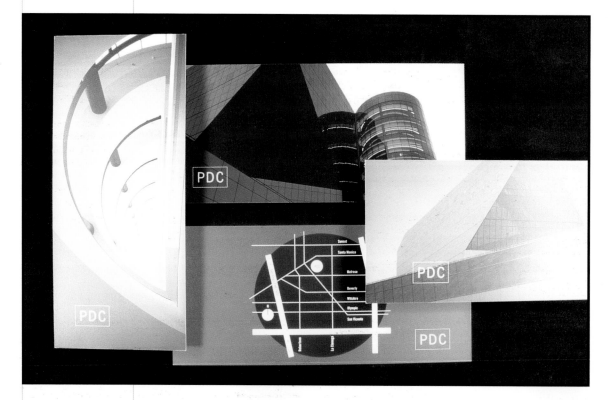

Held together by architectural points of view which alleviate some the intimidating aspects of the building, a postcard series, above, is used for announcing shows, events, gallery openings, and thank-you cards.

The twelve-story building, designed by Caesar Pelli, has become an area icon, known in the community for several years as the big blue whale. The minimal two-color printing reinforces the PDC's identity and keeps things simple, as seen in the letterhead system at right.

太平洋設計中心 Pacific Design Center パシフィック・デザイン・センター Centro de Diseño del Pacífico

Contract Place signage materials, left, are simple acrylic with a metal back, with reverse-side vinyl letterforms.

Much as facets in a diamond add to the quality of the stone, the foundation of the Center is accented by ever-changing banners, below.

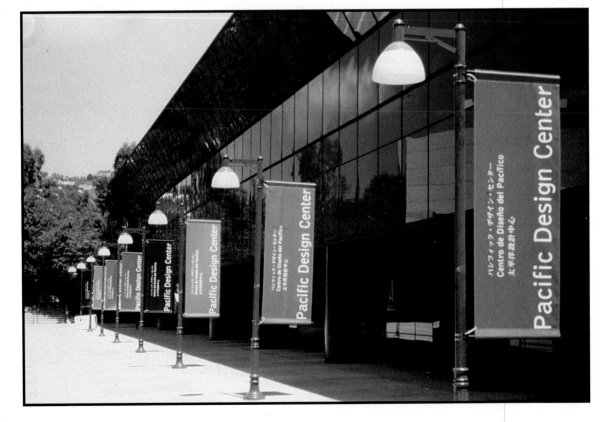

that PDC manifested that idea, within their own four walls."

Morioka worked for several years in Tokyo with Landor Associates, an international corporate identity firm, where standards manuals became second nature. The PDC standards manual broke many rules, empowering users with loose boundaries. Described as a kit of parts, the "virtual identity" rules were simple: Don't change the colors, use the appropriate typefaces, utilize a few simple shapes—circles, squares, rules. This simple idea not only enabled the in-house design and marketing departments, but also presented PDC tenants with a method for broadening their own identities by endorsement of the overall identity.

"We consider ours low-fat design," states Morioka. "Others like to put icing on the cake. Sean and I are more subtractive; we like to have a good piece of cake, without any icing. That relates to how we look at the PDC identity. It is pure. You don't need to throw anything else on it. Anything else would change or cloud the meaning."

Getting people on board any program is often half the battle, and in the case of the PDC, became crucial. Several tenants felt they weren't being well served by the Center and considered not renewing their leases. These tenant laments reached Adams/Morioka, who were working on materials for WestWeek, the annual mart week. The team had conceived the image of a globe, split in longitudinal and latitudinal segments, filled with a variety of photographs reinforcing the

All Things Must Pass:

Giving up the Ghost

"HEARTBREAKING" IS HOW Noreen Morioka describes in resigning the Pacific Design Center account. It happens to every design studio or advertising agency: a rapport is established, a working relationship is built with a key player, and then . . . the contact person moves on to greener pastures. That is the case with the PDC, with President Andy Wolf taking on another position within the furniture industry.

A new president, with new priorities and positions and a new design team with whom he had previously been associated came on board. Presidents get where they are for having a very specific point of view. While it may seem apparent that continuity would be appropriate, that building equity would be key, there is no guarantee that the vision of outgoing management will match that of new management, regardless of the scope of operation.

The focus on the Pacific rim and multiple languages has since been dropped. "It was wonderful to even think we had the opportunity to be contributing to a cultural change within that part of L.A.," states Morioka.

"To be Zen about it, change is always good. We really grew," she says a bit ruefully. "When you walk away from a relationship like that, you realize how much love and passion you have, which you take for granted every day. I really enjoyed that account."

Top, the *Progressive L.A.* lecture series addresses the idea of the PDC as a center point of design in Los Angeles. The five-week series addressed interior design, landscape design, graphic design, environmental design, and architecture, within Los Angeles.

A 6 inch x 9 inch (16 cm x 23 cm) envelope houses several components, leaving an impression of the variety of undertakings at the PDC: an announcement for "How-To at PDC," information about the concierge service, and the addition of a new marketing liaison.

Opposite page, poster announcing the annual open mart showcase.

show's theme, "How the West was One." The design studio suggested asking showroom tenants if they had new products they would like to showcase. They enthusiastically came on board, as a poster, newsletter, program guide, and other components were rolled out for the occasion.

The WestWeek program guide explained the daily schedule to the thirty-thousand-plus people attending the show. Designed to fit in the breast pocket, four separate covers were designed, with a common program interior. "An identity should really create an environment, particularly for a place that addresses interiors. We were consistently examining how people respond to the PDC and take part in it." To that end, the different brochure covers sticking out of pockets added to the "landscape" as customers mingled during the WestWeek festivities.

"Lou Danziger [designer of the CBS logo, among others] made the comment that a great designer is not made from one piece, but from a series of wonderful pieces," states Morioka. "I think the PCD has started that, taking the first step to becoming the center of West Hollywood. But it still needs to keep progressing."

PDC

PACIFIC DESIGN CENTER

GREEN ACRES
GRETEMAN GROUP

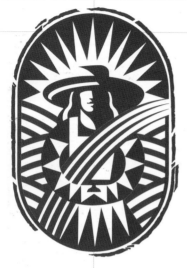

A wholesome farmgirl with wide–brimmed hat and apron combine with sun and plowed fields to create a memorable image for this health–food store and delicatessen.

CLIENT
Green Acres
Wichita, Kansas

CLIENT CONTACT
Barbara Hoffman, President

DESIGN FIRM
Greteman Group
Wichita, Kansas

ART DIRECTOR
Sonia Greteman

DESIGNERS
Sonia Greteman, James Strange

ILLUSTRATOR
Sonia Greteman

A Market for Perennial Growth

FOOD IS A NECESSITY, BUT WHERE one shops is often more than a matter of convenience. In the Midwest, "breadbasket of America," it has, ironically, taken longer for pesticide-free, natural markets to catch on.

Lacking the advertising resources of a national chain, the natural foods market Green Acres turned to Greteman Group to get the most punch from its marketing dollars. To combat health-food stores' reputation for overpricing their products and not providing value for money spent, the strategy was to develop an identity and marketing pieces that conveyed the attributes of honesty, simplicity, earthiness, and good humor.

Many of Green Acres' customers are baby boomers striving for a more natural lifestyle. Greteman Group targeted this health-conscious, forty-something generation as it developed a direct-mail campaign. Using the knowledge that many of the store's customers had been hippies in the 1960s, had fallen away from that lifestyle in the 1980s, and were back again in the 1990s embracing a more natural lifestyle, Greteman Group developed a direct-mail, open-house invitation that was a simple pack of peas with a playful headline.

The identity has been applied to everything from aprons to display tags, with an internal group producing newsletters and newspaper inserts. The increasing community awareness has increased revenue and a loyal clientele.

Above, a direct mail piece announcing an open house features nostalgic art and humorous text.

Producing an exceptional 33 percent response rate, the low production costs of fifty cents each were easily justified.

Serving as a traveling billboard,
the Green Acres paper bags present
the company's health-conscious
philosophy with text that reads in a
friendly and conversational manner.

RIPPELSTEINS

VAUGHN WEDEEN CREATIVE, INC.

On the Frontier
of Fashion

R I P P E L
■ ■ ■ ■ ■ ■
S T E I N S

Cool, clean Futura Bold makes an elegant logotype. Supporting fonts include Univers for text and Linoscript for display use.

SANTA FE IS KNOWN MORE FOR arts and crafts created in the overlap of Native, Hispanic, and Anglo cultures than in areas of fashion. Rippelsteins, a high-end men's accessories shop located in the heart of the city's historic district, has to vie with those art galleries, restaurants, and boutiques, defining a presence as stylish and inviting as any of them.

Stylist, space designer, and artist David Moreno was commissioned to design the interior of the new store. He in turn recommended Vaughn Wedeen Creative, whom he had worked with on a furniture catalog.

Because of the store's unique upscale product line and interior, it was important to have a unique contemporary identity that could be carried through signage, direct mail, and hang tags. Additionally, with a warm and friendly tag line, "a store for men and the people who love them," the identity had to wed that tone to the criteria already established.

Initial layouts used different typefaces for each letter of the name (a play on the variety of accessories available). But during that process Moreno came across a 1950s era photograph of a small freckle-faced boy in a sailor's cap. The iconic image was chosen to represent "the little boy" in all men, furthering the friendly tone.

Ongoing advertising and collateral has succeeded in continuing to create an awareness for the tiny boutique.

CLIENT
Rippelsteins
Santa Fe, New Mexico

CLIENT CONTACT
John Rippel, Proprietor

DESIGN FIRM
Vaughn Wedeen Creative, Inc.
Albuquerque, New Mexico

ART DIRECTOR
Rick Vaughn

INTERIOR DESIGN
David Moreno

COPYWRITER
David Moreno

PRODUCTION
Chip Wyly

Ads and a series of mailers, right, bring just enough past into the present, creating an easygoing, but knowing image of masculinity.

As a **boy**, you tried running away from home.

Today, a business trip is

as **adventurous**

as you get...

R I P P E L
■ ■ ■ ■ ■ ■
S T E I N S

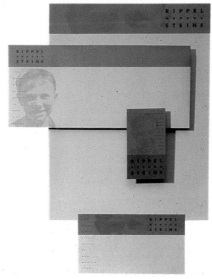

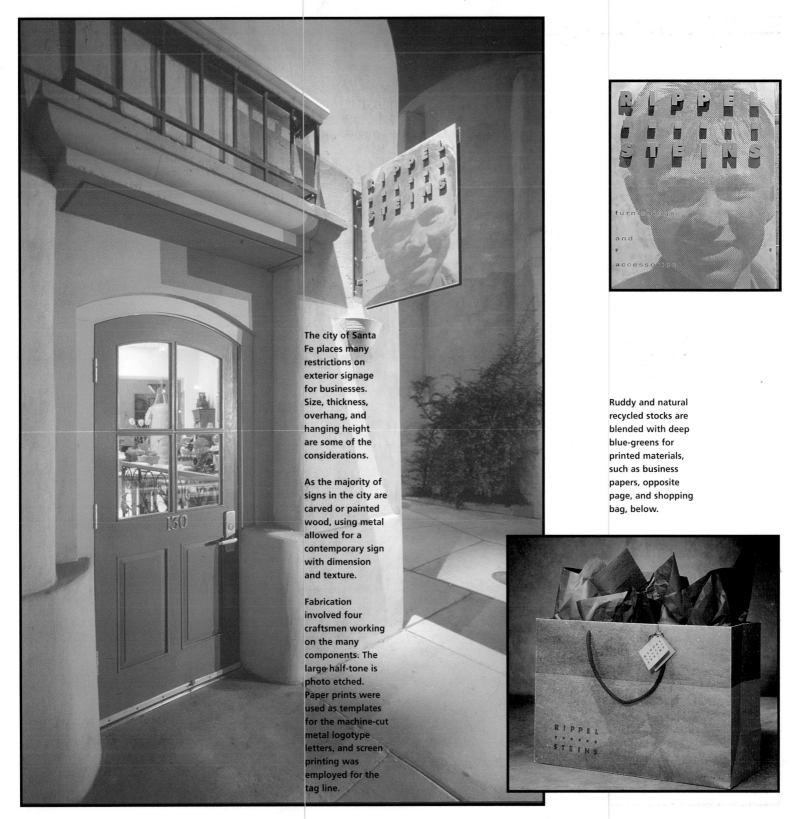

The city of Santa Fe places many restrictions on exterior signage for businesses. Size, thickness, overhang, and hanging height are some of the considerations.

As the majority of signs in the city are carved or painted wood, using metal allowed for a contemporary sign with dimension and texture.

Fabrication involved four craftsmen working on the many components. The large half-tone is photo etched. Paper prints were used as templates for the machine-cut metal logotype letters, and screen printing was employed for the tag line.

Ruddy and natural recycled stocks are blended with deep blue-greens for printed materials, such as business papers, opposite page, and shopping bag, below.

KATHLEEN SOMMERS
GILES DESIGN INC.

Timeless Simplicity:
A Fashionable Update

The simple balancing act of two letterforms set in Univers 47 Condensed Light creates an elegantly refined logo.

SAN ANTONIO CLOTHING designer Kathleen Sommers has a loyal following, but in spite of her change and growth as a designer, her visual identity was dated. Sommers's boutique features her own designs, which over the years have evolved into a blend of rustic natural fabrics with spare lines and simple construction. The shop also carries a select group of high-end clothing, organic bath products, gift items, and books, many of which promote a spiritual, Earth-friendly lifestyle. An enhanced version of Sommers's signature served as a logo for a number of years, but neither logo nor packaging communicated the aesthetics or philosophy of the changes in her store or merchandise.

Spare, elegant, and straightforward, the new logo is pared down to essentials. The lowercase, vigilantly kerned wordmark and delicately poised logo evoke the purity of line that characterizes Sommers's clothing designs. Her devotion to living lightly on the Earth is acknowledged by the three organic shapes used in package labeling —a stone, a stick, a blossom. According to Giles, the images convey a womanly sensuality and add a counterpoint of warmth and texture to the stark logo.

The new identity has blended seamlessly with Sommers's retail and wholesale businesses, creating a look that is as simple as it is timeless.

CLIENT
Kathleen Sommers
San Antonio, Texas

CLIENT CONTACT
Kathleen Sommers,
Owner and President

DESIGN FIRM
Giles Design, Inc.
San Antonio, Texas

ART DIRECTOR
Jill Giles

DESIGNERS
Jill Giles, Stephen Arevalos, Cindy Greenwood, Warren Borror

COPYWRITERS
Cory Russell, Tyra Simpson

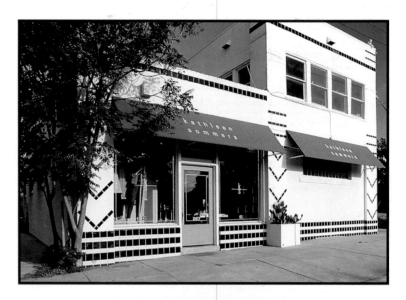

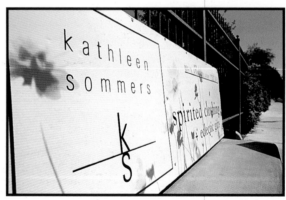

At top, the simple lines of sleek, tailored, tweedlike awnings act as counterpoint to the building's decorative façade.

Below, spare design and subdued flower photograms bring style to bus benches.

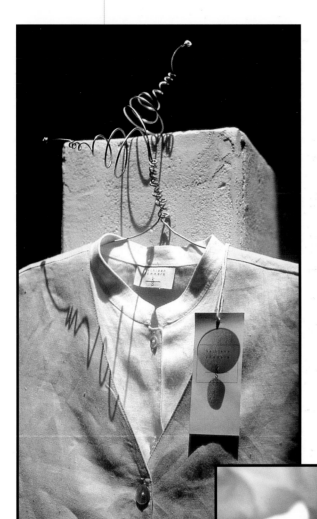

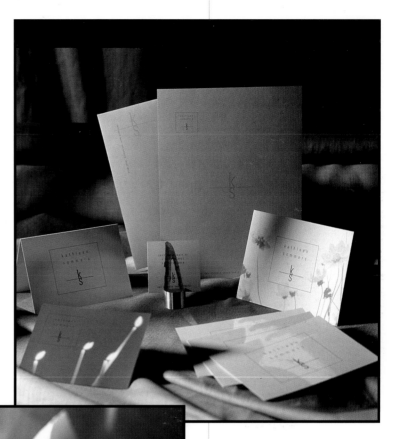

Above, sepia quad-
tones and earthy
greens on a matte
stock contribute to
elegant hangtags.

Above, organic
forms and colors
grace a series
of promotional
cards, note cards,
and square
business cards.

At left, labels are
printed in muted
colors on uncoated
stock and applied
to kraft bags and
boxes, sometimes
with a grasslike
paper ribbon.

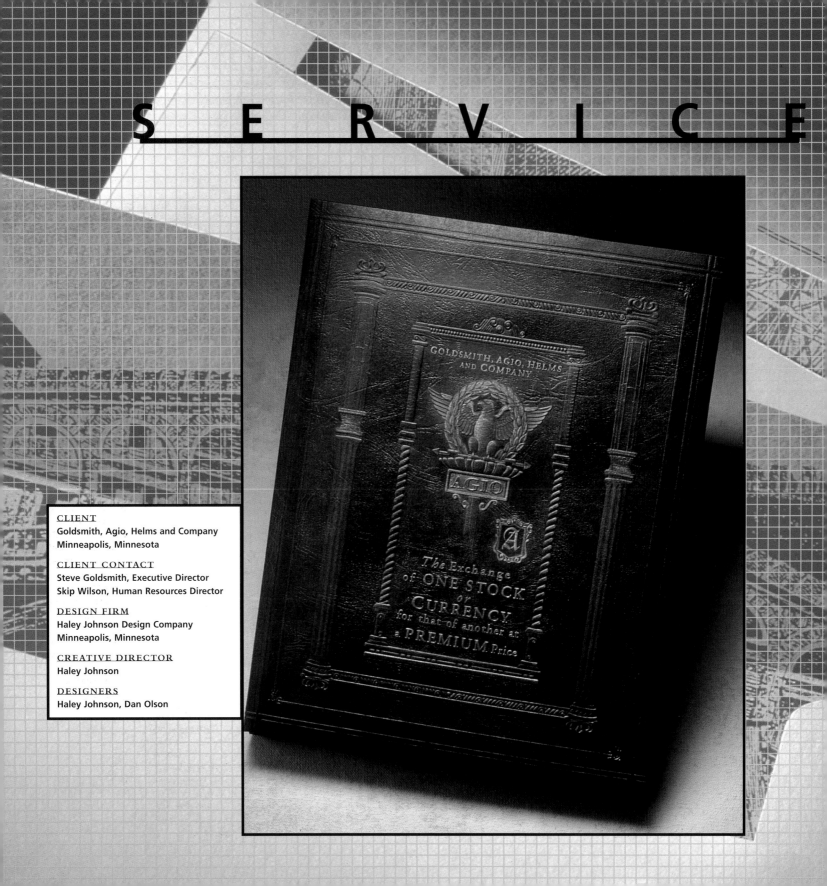

SERVICE

CLIENT
Goldsmith, Agio, Helms and Company
Minneapolis, Minnesota

CLIENT CONTACT
Steve Goldsmith, Executive Director
Skip Wilson, Human Resources Director

DESIGN FIRM
Haley Johnson Design Company
Minneapolis, Minnesota

CREATIVE DIRECTOR
Haley Johnson

DESIGNERS
Haley Johnson, Dan Olson

GOLDSMITH, AGIO, HELMS AND COMPANY
HALEY JOHNSON DESIGN COMPANY

Creating a Mythology:
When Reality Equals Perception

MYTHS, ASIDE FROM TALES OF SUPERNATURAL BEINGS, heroes, and ancestral spirits, also deal with recurring themes or character types that appeal to the consciousness of a people by embodying cultural ideals or by giving expression to deep, commonly felt emotions. Industries and services of all kinds often rely on myth, some implicitly, some explicitly. On a small mountain overlooking Birmingham, Alabama, stands a statue of Vulcan, the Roman god of fire and craftsmanship, especially known for metalworking. The statue has come to symbolize a city built on its ore deposits and the subsequent steel industry that grew around it. Because of this postbellum growth, the city of Elyton went so far as to appropriate the name of sister steelworking city, Birmingham, England, in 1872. An identity had been created to match the vision of the city fathers.

When Steven Goldsmith started his firm, he too appropriated a name that had significant meaning, though it may have originally been perceived as just another name on the letterhead. Goldsmith, Agio, Helms and Company is a leading and internationally respected investment banking firm whose professionals specialize in representing sellers of private, public, and closely held companies. In the context of corporate mergers and acquisitions—their focus—the firm has one of the largest middle-market practices (transactions between $15 million and $250 million) in the U.S. concentrating in exclusive sell-side representation. Over the years, the firm has represented clients throughout the U.S., Europe, and the Pacific Rim.

In 1977 Goldsmith added the name—or word—*agio* to his letterhead. According to Goldsmith, *agio* is not a principal . . . it's THE principle. Agio is defined in the *Dictionary of Business and Economics* as, "The exchange of one currency or stock, for that of another, at a premium price." In this manner the firm set out to position itself as consistently demonstrating its experience, resources, and capabilities in obtaining premium purchase prices far above conventional norms.

With a name in place, Goldsmith next turned to finding a way to visually represent his vision for the firm, understanding the impact of successful visual communication. He found the griffin, a mythological creature possessing many attributes and known as a guardian of gold, which became that representative.

Designed by the budding Charles S. Anderson, the mark served for a decade. Along with the logo, Anderson did an analysis of contemporary industry color schemes and suggested a new palette that was unique for the field and the times.

Later, due to prior commitments, Anderson recommended designer Dan Olson to design a capabilities brochure for Goldsmith. The brochure, *Quality of Success,*

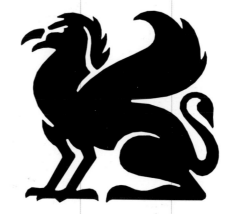

According to the *Dictionary of Symbolism*, "The griffin, a fabulous mythological animal, is symbolically significant for its domination of both the Earth and the sky because of its lion's body and eagle's head and wings. It has typological antecedents in ancient Asia and is also the source of the Hebrew cherub. In Greece the griffin was a symbol of vigilant strength as guardian of gold. The griffin was also an embodiment of Nemesis, goddess of retribution, and turned her wheel of fortune. Frequently appearing in the applied arts, the beast was used in heraldry, indicating a combination of intelligence and strength."

Opposite page, a richly embossed cover with highlights of gold and classic typography looks more like it was from the 1890s than the 1990s on this superlative folder.

In competition with longer established, better recognized firms, this folder and its components, sent prior to meetings, sets the stage for the "experts from afar."

With airline tickets between $900 and $1,000, the per unit collateral material costs of $150–$175 are easily justified, creating an indelible impression of substance and style.

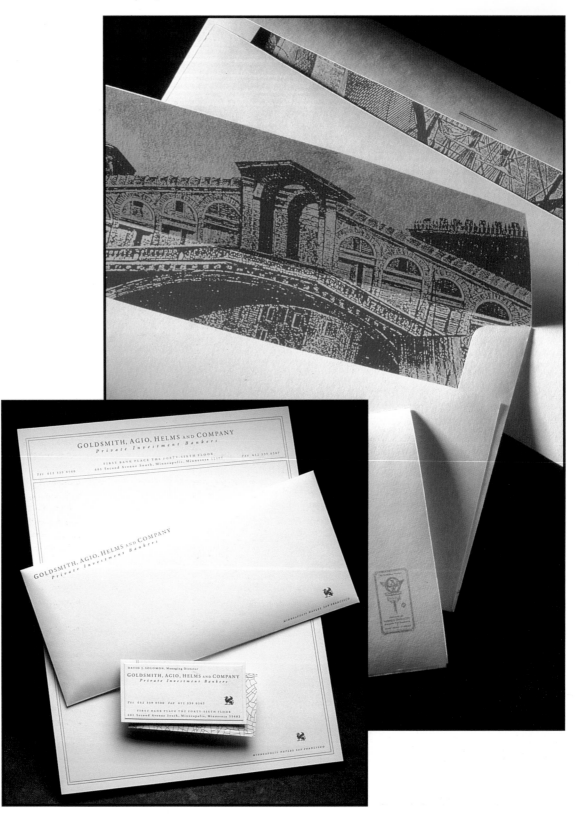

proved a successful turning point for Goldsmith, et al. Goldsmith, a long-time advocate of the benefits, both quantitative and qualitative, of a carefully planned corporate identity, stands firm in his belief that "if you can't be with [the client], the next best thing is the printed word." This conviction and an investment "in six figures" in the *Quality of Success* piece ended up bringing the firm "tens of millions of dollars in new business."

By the mid-1990s the brokerage house was moving from a 1980s style suburban office park to an historic building in downtown Minneapolis. Its identity, which had also been designed in the mid-1980s, had begun to look dated; its gray and mauve palette, which had once been *au courant*, no longer seemed appropriate.

Sharply aware of the equity inherent in the downtown location, the partners were equally aware of the trappings of successful corporations. Furniture, carpeting, and artwork were sought with an eye toward an atmosphere of professional confidence. Cherrywood-lined walls, marble floors, and antiques would contribute to an old-school aura. Although by now the firm was fifteen years old, it was still considered fairly young in the area of finance, and a long-established "look" would give it an air of tradition—of credibility. Within the banking world, slick, contemporary looks don't go far in matters of trust and confidence.

But a "look" isn't everything. The ability to back it up, by talking the talk, AND walking the walk, is what truly separates the wannabes from the real

A collection of art and typography from a variety of reference materials was put together to inspire the design team in recreating a specific era, evoking old-world quality.

This page, "tombstones" are printed on parchment and in this case bound for prospective clients with vellum flysheets and textured cover.

Opposite page, clean and classic on the outside, envelopes are lined with offset engravings of majestic old-world architecture. Quality cream-colored paper is soft, almost buttery. Adobe Garamond, chosen for its classic qualities, was printed by letterpress.

Business cards, seen below, have an embossed beveled edge and a distinctive texture printed on the back, all referring to age and antiquity.

movers and shakers. "Goldsmith is very unique within the world of finance," says Johnson, "in that they will take risks in how they portray themselves."

Willing to move and shake, Goldsmith again turned to Olson for design services. By this time Olson had teamed with designer Haley Johnson, whom he had met when both were working for Anderson. They had been in business together for a week.

Olson and Johnson generated a proposal detailing the scope of work, after spending considerable time discussing the ramifications of the firm's move. With a lot of design under their belts in areas such as packaging, the duo brought a new way of looking at things to the table. Their intent: to bring a unique solution to an industry not known for visual daring.

Olson and Johnson both worked on refining the griffin, rendering it in a squatter, squarelike position. Though long integrated as part of the company philosophy, the word *agio* became visually significant with a mark of its own: an eagle behind a wreath of olive leaves.

While the basic business papers—letterhead, envelope, press release, fax form—are essential in day-to-day business, "tombstones" play a special role within the industry. These transaction "tombstones" record the done-deal, making them essentially "carved in stone." Much like the trophies of big-game hunters, these certificates often line office walls, and in this case Goldsmith wanted certificates worthy of framing. Catalogues of these recent transactions are bound in-house and then sent to prospective clients.

Going Over the Top in the Name of Quality

"MY GOD, WHAT IS THIS?!" IS exactly the reaction Steve Goldsmith expects and gets from prospective clients. "The look is conservative, but it has an extravagance that may intimidate some," says Johnson, yet "there is a level of quality that was the main criteria."

Goldsmith concurs, "We believe in setting the right tone. Is there a possibility of offending some people [with this lavishness]? Absolutely. But people want to work with successful people. We must radiate success. You must be able to attract and deliver. One without the other is a going-out-of-business strategy."

In the very rarified atmosphere of investment banking, with 10,000 mid-level transactions in 1996, and more than 10,000 firms competing, executing work at the highest level of the scale—1 or 2 percent—brings poignancy to the mundane term "cutting edge." Praise from clients—"I have never been as impressed with a corporate packaging of *bona fides*. Yours are the finest materials we consistently see"—acknowledges the differentiation the firm has achieved in a high-test market.

Distinguish. The task.
Distinguished. The firm itself.

Branding the company as first-class in every respect presents attributes and characteristics, which have brought great success. Says Goldsmith, "We wouldn't be where we are today without the corporate communication pieces we developed."

Early on it was found that gold-leafed edges for the "tombstones" would be too expensive, though that was the desired look. Details like this were figured out before going into production, though not necessarily before presenting it to the client. This technical and financial dilemma was solved by the printer pressing the printed sheets together and spray painting the edges with gold. "The client fell all over those little touches," said Johnson. "He loved them."

Folders, common to all businesses, are rarely as elaborate as the tri-fold produced for the firm. The folder, which contains a bound copy of recent "tombstones" and listing of capabilities and credentials, is an eloquent piece that weighs in as heavily in the hand as it does visually.

An extra-large sculpted bronze die was made for the tri-fold from drawings supplied by Johnson. Her final hand-drawn, black pencil illustration, based on extensive research, was drawn on tracing paper to create the desired texture. A second drawing, again on trace, was used for the gold ink highlights. Black ink was printed in two passes on the black uncoated leatherette stock. Ever the demon for detail, the black passes were from art created by a rubbing of that same leatherette texture, adding a sublime level of antiquity.

Press releases, once printed in primary reds and yellows, now possess a classic, timeless look, with two earth tones on a cream colored stock, rounding out corporate communications.

Walking in to the new offices, the designers were amazed at how close they came to the image and perception

This 8 inch x 5 inch (20 cm x 13 cm) moving announcement postcard, took a leap with its artful collage, knowing that the client was attuned to art.

that the client called for. "It was amazing," said Johnson, "how we were on the same track as far as thinking. We didn't see the space until it was finished."

Though much of the design that comes from Minneapolis seems to have some kind of historical basis, as witnessed in recent design annuals, most identity projects are in what has become considered traditional—the stripped-down look of modernism.

For Goldsmith, Agio, Helms and Company, their identity, attitude and actions have become one, successfully supporting three offices in Minneapolis, Los Angeles, and Naples, Florida, with the firm outgrowing its 46th-floor offices in Minneapolis and taking over the 47th floor as well.

Playing cards, another version of the transaction "tombstones," represented in this "deck of deals," highlight recent mergers and acquisitions. At top, a laser comp.

PRONTO REPRODUCTIONS
TELMET DESIGN ASSOCIATES

Strengthening an
Existing Identity

PRONTO

The original logo,
a letterspaced,
all-caps Univers 67,
bold oblique,
made use of a
custom-drawn *N*,
which has been
reiterated in the
new logo, above.
A modified Futura
Bold is used in
conjunction with
Letter Gothic as a
secondary font.

RECOGNIZING THE NEED TO BE perceived as vital in any industry is a small but crucial component of staying in business and staying on top. As the field of communications has grown at an enormous rate over the past several years, tangential businesses likewise show growth—and competition.

Pronto Reproductions' sole purpose in redesigning its identity was to address that issue head on. According to President Wayne Burlington, there were three areas of concern to be addressed for his small print shop's identity. First, to project a stronger, bolder image through the use of typography, scale, and color, but not to make drastic changes to the existing palette of red, yellow, and blue, in which there was almost a decade of equity. Second, there was a need for overall consistency, which meant reviewing existing materials and updating them as necessary. Third, and most important, they needed to solidify an identity that reflected technological changes and foresight toward "printing for the twenty-first century."

For Telmet Design Associates, this provided an opportunity to rework the original identity they had designed in 1988. By the mid-1990s, Telmet felt the original logo and look were too "wimpy" for current aggressive marketing requirements. The resulting identity met with approval from clients and reaffirmed Pronto's presence.

CLIENT
Pronto Reproductions
Toronto, Ontario

CLIENT CONTACT
Wayne Burlington, President

DESIGN FIRM
Telmet Design Associates
Toronto, Ontario

ART DIRECTOR
Tiit Telmet

DESIGNERS
Robert Farrell, Joe Gault

Above, bold color fields on a bright
white paper create a powerful look.
The previous system, while using the
same color inks, was less dramatic with
its use of screens, gradating from
100 percent to zero on a flecked paper.

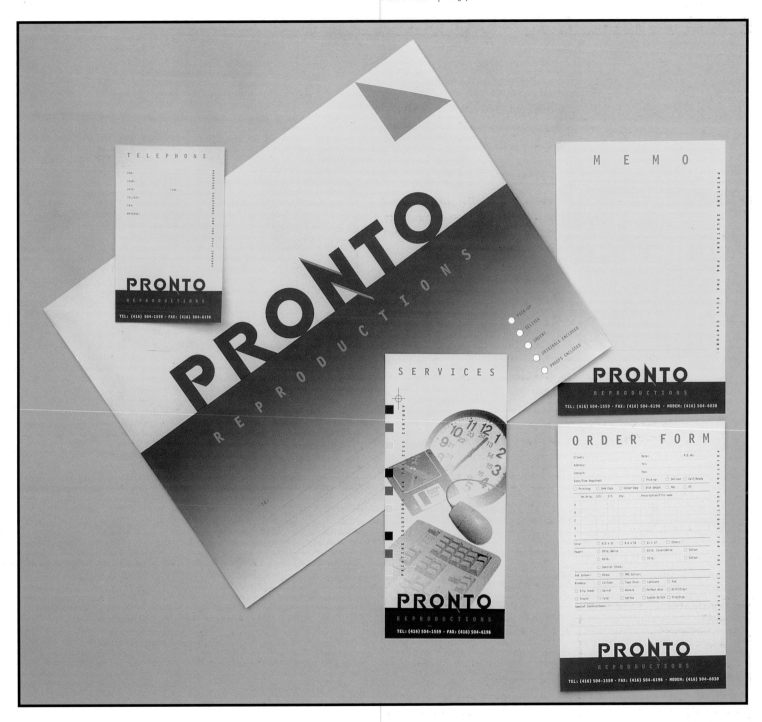

As much of Pronto's business is walk-in, the large envelope, above, serves as a walking ad or minibillboard, once they have left the print shop.

KAZAN SOFTWARE

KAMPA DESIGN

Corporate Philosophy:

Company Cornerstone

For Kampa, who specializes in logos and lettering, the company's name provided him with what he considered good letters to work with: a bit of symmetry and angular capital letterforms.

FAMILY NAMES HAVE LONG been attached to many firms that take pride in the personal attributes they believe are epitomized by that name. In that vein, the Kazan identity represents a philosophy that has allowed employees to create meaning instead of being limited by a meaning-loaded word. The name (combining the names of two partners' children) represents the commitment to family that Kazan promotes. The company encourages people to spend time at home, not to work overtime, and to bring spouses and children to company parties and events.

Kazan Software provides product development services to software product companies on a contract basis. They design products, write and test computer code, and deliver parts of or whole products to their customers. Kazan often serves as an extension of customer development teams—and as an ongoing part of their organizations.

Kazan's marketing plan suggested a corporate identity that supported the ideals and concepts of the company (they're high-tech, they're fun, they're software engineers) and was suitable for use on future product packaging. They also planned to use this identity online and wanted a mark that would lend itself to several media.

The Kazan name is important to the company. They like their logo, their company colors. But the meaning comes from within. And no name, logo, or marketing strategy can provide that.

Above, preliminary logo designs explore both marks and logotypes, all favoring energy and vitality.

At right, breaking the taboo of altering the corporate mark, Kampa has fun with the logo —with client approval—for children's T-shirts and Kazan's first year anniversary boating party.

CLIENT
Kazan Software
Austin, Texas

CLIENT CONTACT
Jim Van Winkle, President, CEO

DESIGN FIRM
Kampa Design
Austin, Texas

CREATIVE DIRECTOR
David Kampa

DESIGNER
David Kampa

Stationery and
website rely on
the extensive
Univers type family,
for crisp, clean
communication.
An embossed, foil-
stamped logo
jumps out from the
business card.

Below, Kazan's
website design
is simple and to
the point.

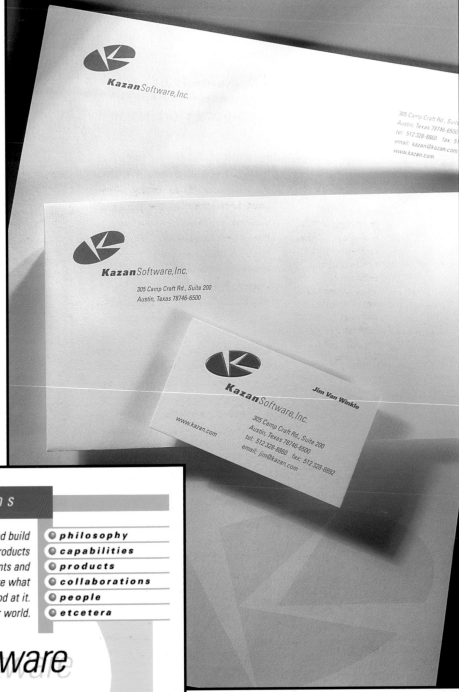

Kazan creates solutions

We design and build
successful software products
for our clients and
ourselves. We like what
we do and we're good at it.
Welcome to our world.

- philosophy
- capabilities
- products
- collaborations
- people
- etcetera

KazanSoftware

305 Camp Craft Rd., Ste. 200 Austin, TX 78746

tel: 512 328-8860 fax: 512 328-8892 email: kazan@kazan.com

DOWNTOWN IMPORT SERVICES
EAT INCORPORATED

Wrench and globe
add up to a quick
visual reference,
symbolizing skill,
expertise, and a
world of knowledge.

Diagnosis:

Identity Overhaul

**WHEN A COMPANY OF
any size makes a change that
may prove significant, it's often**
time for reevaluating business plans and
operating procedures. After being located
in a small shop for fifteen years,
Downtown Import Service, specialists
in the repair of European and Japanese
automobiles, bought a significantly
larger building and moved their opera-
tion. Besides relocating, owner Dick
Jobe invested heavily in the latest tech-
nology, equipment, and tools to create
a state-of-the-art facility.

With these developments and
expenditures came the sensible idea
to aggressively market his company,
capitalizing on his firm's advancements.
EAT Incorporated was called in to cre-
ate all identity and marketing materials.

With a mailing list of over five
thousand existing customers and access
to lists of all Missouri Volvo, Saab, and
Honda owners, Downtown Import
Service began a series of direct market-
ing campaigns. The first, aimed specifi-
cally at Saab and Volvo owners, used
whimsical vanity plates that Jobe uses
on his own vehicles. The second cam-
paign highlights services in a snappy
newspaper-headline fashion.

At the end of their first fiscal year
in the new location, Downtown Import
Service saw a growth of over 170 per-
cent in sales. Jobe believes part of this
increase in business is due to a new
location and facility, but he attributes a
larger share of that growth to a fine-
tuned identity.

CLIENT
Downtown Import Services, Inc.
Kansas City, Missouri

CLIENT CONTACT
Dick Jobe, President

DESIGN FIRM
EAT Incorporated
Kansas City, Missouri

ART DIRECTOR
Patrice Eilts-Jobe

DESIGNER
Patrice Eilts-Jobe

ILLUSTRATOR
Kevin Tracy

TYPOGRAPHER
Kevin Tracy

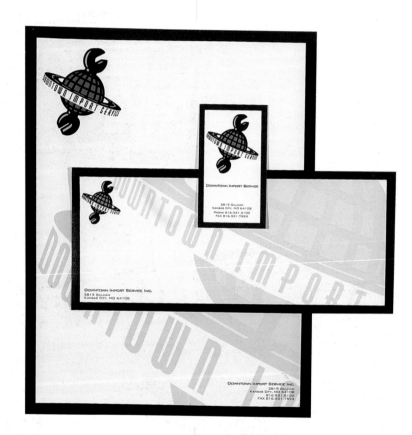

Promotional materials
have included watch
faces, car window
shades, mouse pads,
key rings, license
plates, patches,
T-shirts, and more.
Above, a bold
stationery system.

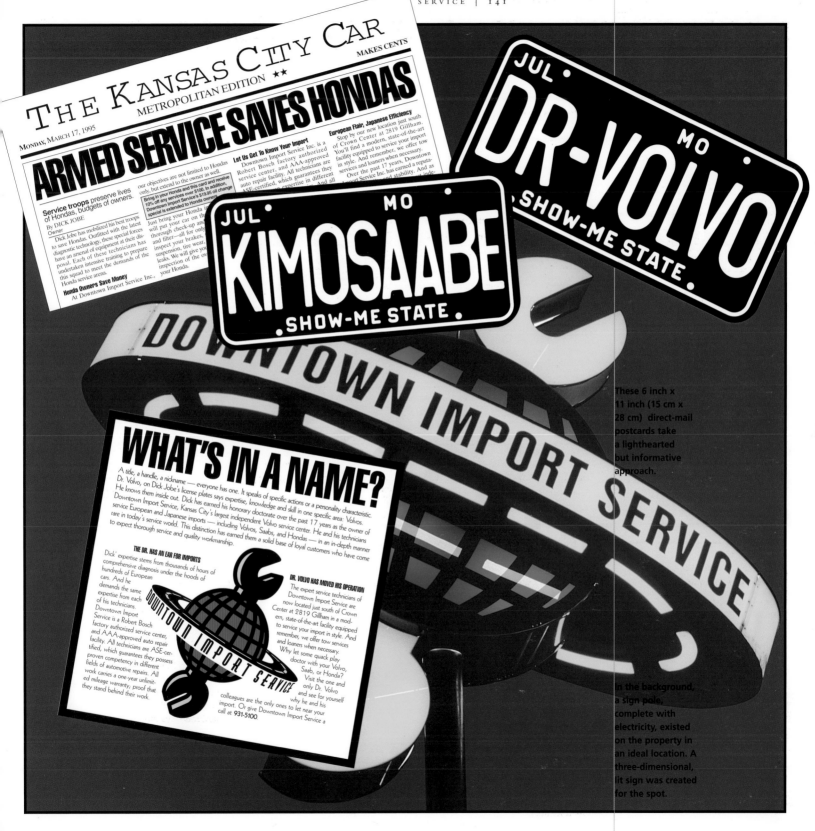

THE KANSAS CITY CAR
METROPOLITAN EDITION ★★
MAKES CENTS

MONDAY, MARCH 17, 1995

ARMED SERVICE SAVES HONDAS

Service troops preserve lives of Hondas, budgets of owners.

By DICK JOBE
Owner

Dick Jobe has mobilized his best troops to save Hondas. Outfitted with the latest diagnostic technology, these special forces have an arsenal of equipment at their disposal. Each of these technicians has undertaken intensive training to prepare this squad to meet the demands of the Honda service arena.

Honda Owners Save Money
At Downtown Import Service Inc.,

our objectives are not limited to Hondas only, but extend to the owner as well.
Bring in your Honda and this card and receive 10% off any services over $100. In addition, Downtown Import Service's $19.95 oil change special is extended to Honda owners.

Let Us Get To Know Your Import
Downtown Import Service Inc. is a Robert Bosch factory authorized service center, and AAA-approved auto repair facility. All technicians are ASE-certified, which guarantees their expertise in different

Just bring your Honda in and we will put your car on the lift for a thorough check-up and change the oil and filter—all for only $19.95. We'll inspect your brakes, tires, and suspension, tire wear, and fluid leaks. We will give you a complete inspection of the overall health of your Honda.

European Flair, Japanese Efficiency
Stop by our new location just south of Crown Center at 2819 Gillham. You'll find a modern, state-of-the-art facility equipped to service your import in style. And remember, we offer tow services and loaners when necessary.

Over the past 17 years, Downtown Import Service Inc. has earned a reputation for quality and stability. And as

JUL • MO
KIMOSAABE
· SHOW-ME STATE ·

JUL • MO
DR-VOLVO
· SHOW-ME STATE ·

WHAT'S IN A NAME?

A title, a handle, a nickname — everyone has one. It speaks of specific actions or a personality characteristic. Dr. Volvo, on Dick Jobe's license plates says expertise, knowledge and skill in one specific area: Volvos. He knows them inside out. Dick has earned his honorary doctorate over the past 17 years as the owner of Downtown Import Service, Kansas City's largest independent Volvo service center. He and his technicians service European and Japanese imports — including Volvos, Saabs, and Hondas — in an in-depth manner rare in today's service world. This distinction has earned them a solid base of loyal customers who have come to expect thorough service and quality workmanship.

THE DR. HAS AN EAR FOR IMPORTS
Dick' expertise stems from thousands of hours of comprehensive diagnosis under the hoods of hundreds of European cars. And he demands the same expertise from each of his technicians. Downtown Import Service is a Robert Bosch factory authorized service center, and AAA-approved auto repair facility. All technicians are ASE-certified, which guarantees they possess proven competency in different fields of automotive repairs. All work carries a one-year unlimited mileage warranty; proof that they stand behind their work.

DR. VOLVO HAS MOVED HIS OPERATION
The expert service technicians of Downtown Import Service are now located just south of Crown Center at 2819 Gillham in a modern, state-of-the-art facility equipped to service your import in style. And remember, we offer tow services and loaners when necessary.

Why let some quack play doctor with your Volvo, Saab, or Honda? Visit the one and only Dr. Volvo and see for yourself why he and his colleagues are the only ones to let near your import. Or give Downtown Import Service a call at 931-5100.

DOWNTOWN IMPORT SERVICE

DOWNTOWN IMPORT SERVICE

These 6 inch x 11 inch (15 cm x 28 cm) direct-mail postcards take a lighthearted but informative approach.

In the background, a sign pole, complete with electricity, existed on the property in an ideal location. A three-dimensional, lit sign was created for the spot.

ABOUT THE AUTHOR

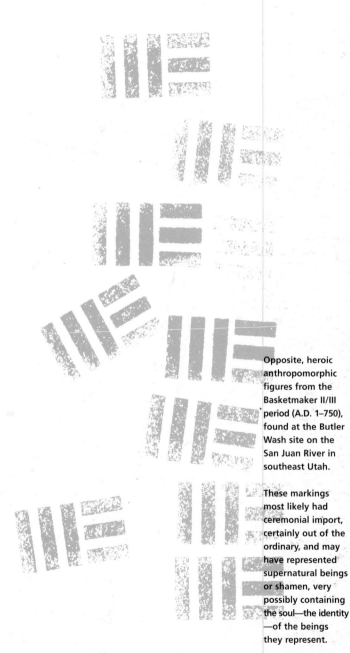

LOOK, I'M THE ONE WHO WROTE THIS BOOK, SO guess who's writing the bio? None of that third-person stuff. I studied design at Massachusetts College of Art, after a brief stint at the Berklee College of Music, where I studied composing, harmony, and arranging.

My journeyman career has involved being a designer for a couple of design boutiques, a museum exhibit design firm, and filling the role of assistant director of design for Boston's largest commercial television station. I had had my fill of people telling me to "pick my battles," as if principles are something one can put on a shelf, so I started working for myself in 1993.

I've done plenty of work for a variety of corporate and institutional clients, and have come close to putting myself out of business by taking on too many projects *pro bono publico*.

Since 1991 I've taught corporate identity, advanced typography, publication design, and a few other design classes as Adjunct Professor at Massachusetts College of Art, The New England School of Art & Design, and Southwest Texas State University. The students learn, I learn. I dig it.

Coming through the ranks and serving as president of the Boston Chapter of the American Institute of Graphic Arts, I had the privilege of working with and befriending some of the greatest people—in many ways—in design in the U.S. (and north and south of the border, too). In 1997, I helped establish an AIGA chapter in Austin. Being involved in organizations such as the American Center for Design, Broadcast Design Association, Society of Environmental Graphic Design, and the International Council of Graphic Design Associations continues the learning process.

I've picked up a stack of awards that are sitting in boxes in the garage for work in any number of given design areas. American Center for Design, New York Art Directors Club, American Corporate Identity, AIGA/Best of New England, Society of Publication Designers, Broadcast Design Association, the Advertising Federation of Austin, *Print*, *How*, *Step-by-Step*, and a few others have thrown me a bone. I'm most pleased that a young lady, with a wonderful German-British accent called one day from Hamburg, Germany, and requested some of my work for the collection of the Museum für Kunst und Gewerbe, in said city. Danke.

I'm from Boston, Massachusetts, and now live in Austin, Texas. To me success is measured in the pursuit of excellence, gratitude, a sense of giving, and love. When I'm not directly involved with design, I prefer to be somewhere on the road or trail, more often than not, off the beaten track. I should have been an archeologist.

Opposite, heroic anthropomorphic figures from the Basketmaker II/III period (A.D. 1–750), found at the Butler Wash site on the San Juan River in southeast Utah.

These markings most likely had ceremonial import, certainly out of the ordinary, and may have represented supernatural beings or shamen, very possibly containing the soul—the identity —of the beings they represent.

DIRECTORY

Adams/Morioka
9348 Civic Center Drive
Suite 450
Beverly Hills, CA 90210
213.660.7797

Margo Chase Design
2255 Bancroft Avenue
Los Angeles, CA 90039
213.668.1055

Big Blue Dot
63 Pleasant Street
Watertown, MA 02172
617.923.2583

Brand Design Co.
P.O. Box 3000
Wilmington, DE 19805
800.888.4390

Corey McPerson Nash
63 Pleasant Street
Watertown, MA 02172
617.924.6050

Michael Cronan Design
42 Decatur Street
San Francisco, CA 94107
415.522.5800

Essex Two
2210 West North Avenue
Chicago, IL 60647
773.489.1400

EAT Design
2 West 39th Street
Kansas City, MO 64111
816.931.2687

Giles Design, Inc.
429 North St. Mary's
San Antonio, TX 78205
210.224.8378

Graffito/Active8
601 North Eutaw Street
Baltimore, MD 21201
410.837.0070

Greteman Group
142 North Mosley
Wichita, KS 67202
316.263.1004

Haley Johnson Design Company, Inc.
3107 East 42nd Street
Minneapolis, MN 55406
612.722.8050

Jager DiPaola Kemp Design
47 Maple Street
Burlington, VT 05401
802.864.5884

Kampa Design
2414A South Lamar Boulevard
Austin, TX 78704
512.441.6831

The Mednick Group
8522 National Boulevard
Culver City, CA 90232
310.842.8444

Melanie Metz Design
110 North College Avenue
Fort Collins, CO 80524
970.490.6157

Nesnadny + Schwartz
10803 Magnolia Drive
Cleveland, OH 44106
216.791.7721

plus design inc.
25 Drydock Avenue
Boston, MA 02210
617.478.2470

PMcD Design
81 Franklin Street
New York, NY 10013
212.343.0400

Richardson or Richardson
1301 East Bethany Home Road
Old Hess Farmhouse
Phoenix, AZ 85014
602.266.1301

Sametz Blackstone Associates
40 West Newton Street
Boston, MA 02118
617.266.8577

Sandstrom Design
The Director Building
808 SW Third, 6th Floor
Portland, OR 97204
503.248.9466

Select
153 West 18th Street
New York, NY 10011
212.929.9473

Skolos/Wedell
529 Main Street
Charlestown, MA 02129
617.242.5179

Spot Design
775 Avenue of the Americas
New York, NY 10001
212.645.8684

Studio Archetype
600 Townsend Street
Penthouse
San Francisco, CA 94103
415.703.9900

Telmet Design Associates
398 Adelaide Street West
Suite 202
Toronto, ON M5V 1S7
Canada
416.504.1101

13thFloor
620 Rosecrans Avenue
Manhattan Beach, CA 90266
310.546.7135

Vaughn Wedeen Creative, Inc.
407 Rio Grande NW
Albuquerque, NM 87104
505.243.4000

Wages Design
887 West Marietta Street
Suite S-111
Atlanta, GA 30318
404.876.0874

Werner Design Werks
126 North 3rd Street
Suite 400
Minneapolis, MN 55401
612.338.2550